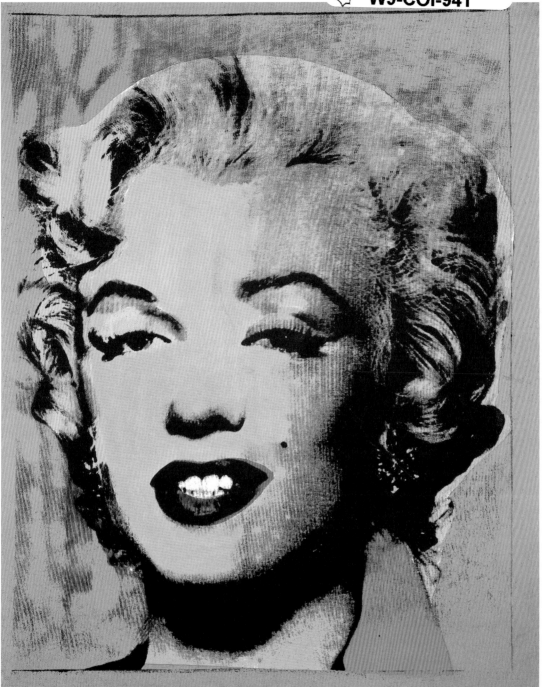

ANDY WARHOL

JOSEPH D. KETNER II

PHAIDON · FOCUS

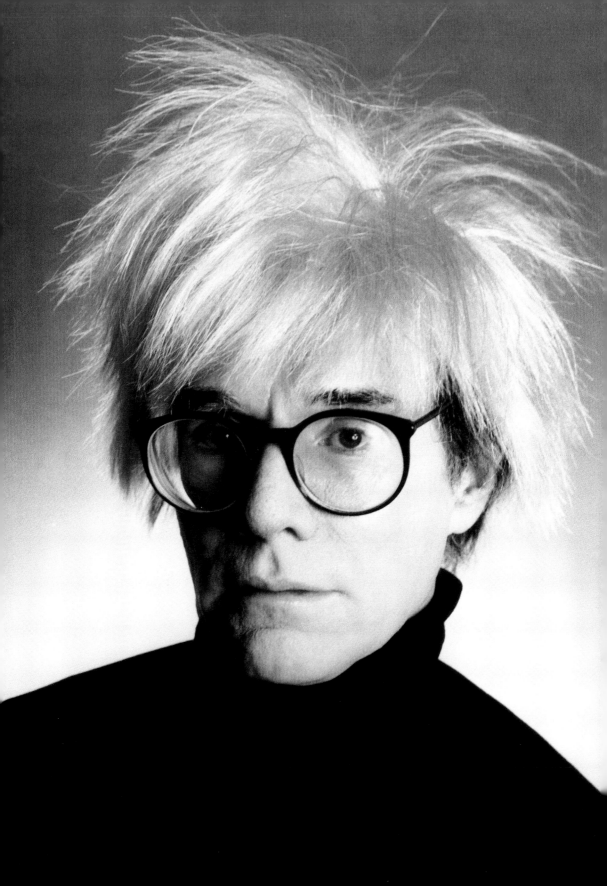

MEDIA MAVEN

Popular opinion crowned Andy Warhol (1928–1987) as the 'Prince of Pop', the artist who created a pantheon of pictures that became icons of American consumer culture in the 1960s. His bold, simple images of soup, cereal, soda and celebrity participated in the Pop Art revolution that introduced to the vocabulary of art such commonplace products as Campbell's Soup and such screen stars as Marilyn Monroe. Warhol rummaged through mass media magazines, films and television, selecting key objects and people that represented his moment in time. He then transformed these media images with a bold, graphic directness that emblazoned them into our collective consciousness. In his paintings, Warhol portrayed an America shaped by the explosive economic growth after World War II and new-found political power. He also scraped the surface of the new America to reveal its darker side, the debris of a culture that littered its landscape with the shredded metal of car crashes strewn about the highways, harrowing suicides, dangerous criminals and the chilling emptiness of state-sanction execution in the electric chair. Warhol's legions of grocery products, troubled celebrities, deaths and disasters, forced us to confront both the benefits of consumerism and the lurking cataclysms and tragedies that marred the idyll. By isolating everyday objects, Warhol allowed us to see them as emblems of American culture.

Warhol created a pantheon of images, marking an era that witnessed the explosion of mass communication media. He recognized that marketing and media defined his generation and he used it as his source and subject. By appropriating photographic images and reproducing them through mechanical processes, Warhol ushered in a fundamental transformation of our visual culture. The visual arts of the twentieth century had been dominated by abstract modern art. In contrast, Warhol reintroduced representational images from everyday life, and reproduced them en masse in his Factory to create an encyclopedia of visual signs. This alteration of the arts – from abstract to figurative and from handwork to the machine-made – continues to characterize the world in which we live. Having abandoned artistic touch and adopted photo-mechanical images as a basis for an individual's artistic practice, Warhol forged the foundation of the cross-media era of conceptually based contemporary art that subordinates traditional artistic issues of medium, style and originality.

◄ Warhol in 1986.

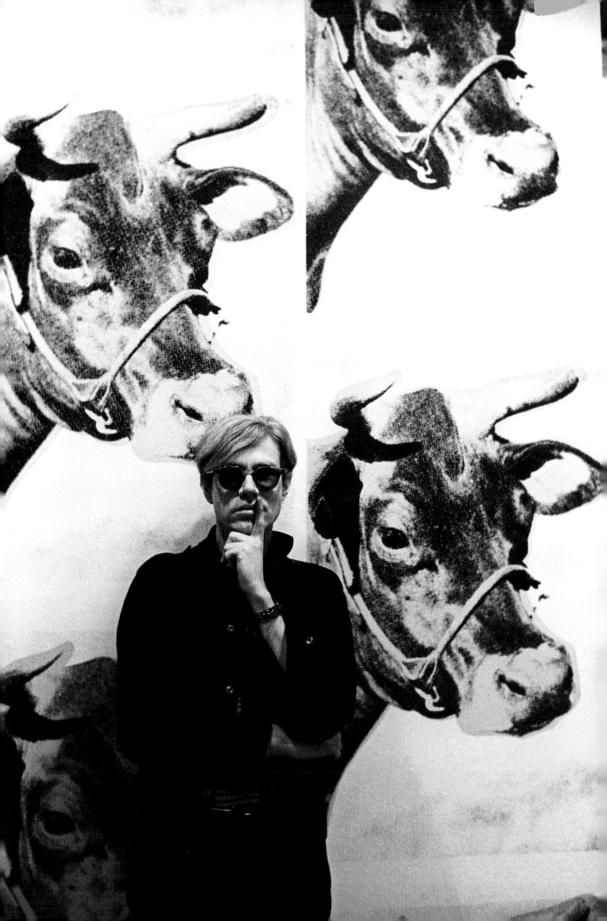

WHO IS ANDY WARHOL?

AN ARTIST OF THE EVERYDAY

Warhol participated in the Pop Art revolution of the early 1960s that elevated representational images of commercial and popular culture into the vocabulary of art. Pop Art resonated throughout the western world, with recognizable images of familiar people and commonplace things that a broad public could understand and appreciate. Through his subjects and media, Warhol was able to communicate with his generation. He rebelled against Abstract Expressionist painting in the United States and Art Informel in Europe during the 1950s, as exemplified by works by Jackson Pollock (1912–1956) and Wols. His training in graphic design and illustration provided him with the tools to wed mass media and high art over the four decades of his career.

As a commercial illustrator in New York in the 1950s, Warhol participated in the 'golden era' of the fashion and glamour industries, when they blossomed on the wings of Madison Avenue marketing. Hollywood continued its exponential growth, promoting an ever-expanding universe of movie stars. By 1960 ninety per cent of American households had a television that served as the domestic altar and the principal purveyor of news and information. In the mind of Marshall McLuhan, a cultural theorist of the 1960s, mass media had solidified the shift from a literary based society. As he put it, 'In the new electric Age of Information and programmed production, commodities themselves assume more and more the character of information.' Warhol understood this sea change.

But Warhol did not simply create instantly accessible works of art. He also cultivated a persona that helped to spawn a new, bohemian subculture, setting trends in art, music and cinema of the 1960s. His eccentric personality and his entourage of acolytes captured media attention and altered the cult of celebrity. At the Factory, as his New York studio became known, Warhol was the wispy doyen, both the voyeur and the provocateur, overseeing a circus of reckless abandon, with drugs, sexual liberation, transgender charades, film, music and a menagerie of the tumultuous life of the 1960s unfolding before him. Warhol marketed his persona in film, television, magazines, night clubs and on fashion catwalks. He fused high art, low culture, high society and the avant-garde into a distinctive amalgamation that attracted the attention of millions and influenced generations of artists. In his art and lifestyle Warhol held a mirror up for us to see the world that we had created.

◄ Warhol standing in front of his *Cow Wallpaper*, 1966.

1
Wols (Wolfgang Schultze) (1913–1951)
Composition Jaune, 1947
Oil on canvas
73 × 92 cm (28 ¾ × 36 ¼ in)
Staatische Museen zu Berlin

PUBLIC PERSONA AND PRIVATE LIFE

Warhol was a complex individual whose public persona and private life
appear to be contradictions. He vamped the New York social circuit, but was
painfully shy and feared contact with others. The man who sat on his chair in
the Factory watching the events unfold before him was, in private, religious,
and lived a quiet domestic life with his mother in a townhouse on New York's
fashionable Upper East Side. He sought celebrity, yet also lived a guarded,
private life known only to a few of his closest confidants. The impression he
made in numerous interviews swung wildly between his dullness, with his
monosyllabic answers of 'Yes' or 'No', or 'Gee, it's great', to glibness, with
eminently quotable responses, such as 'I'll be your mirror'. Both the stubborn
and the flip remarks masked the piercing intellect that the artist expressed
through his work.

[2]

The contrast between Warhol's public and private personas parallels the
range of his art and his career. As a public figure he claimed to represent
the common person with such strappings as Coke, hamburgers and chicken-
noodle soup. He championed art as commerce and wanted to become
a machine, cranking out serial images of Marilyn, Elizabeth Taylor, and
Flowers in his popular Factory. Yet, he always identified himself as a painter
and aspired to be compared to the world's great artists, treating the 'serious'
subjects of politics, religion and death. He rebelled against tradition and
separated himself from his predecessors, the Abstract Expressionist painters,
seeking 'to do new ideas'. Ironically, throughout his life he admired and
emulated those artists. Early in his career, he advocated interpretative con-
tent in his paintings, saying they were a 'statement of the symbols of the
harsh, impersonal products and brash materialistic objects on which
America is built today'. Then, at the height of his Pop celebrity, he could
reverse direction and emphasize the superficiality of his work, saying,
'If you want to know all about Andy Warhol, just look at the surface: of my
paintings and films and me, and there I am. There's nothing behind it.'

[2, 3]

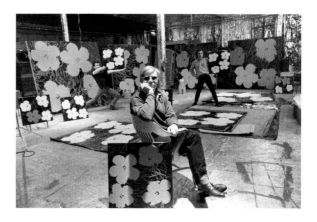

2
Andy Warhol with *Flowers* at
the Factory, New York, 1964

WHICH WARHOL DO WE BELIEVE?

Who was that man behind the glasses quietly observing the world unfolding? Who was that haunting figure floating like an apparition in a void, as in his self-portrait of 1986? Warhol possessed a sense of paradox, contradiction and mystery. The mercurial Warhol was rich and complex enough to embody both the intellectual and the showman.

Warhol's images typified 'Pop' America and resonated internationally. He is one of the few visual artists whose name, face and work are recognized around the globe. Certainly, more is written about Warhol than any other artist. Analysis of his images and gossip about his lifestyle have appeared in thousands of books, newspapers and magazines. For an artist whose career spanned nearly forty years, it is ironic that his reputation is founded predominantly on his Pop Art of the 1960s. What did Warhol create over the other thirty years of his active life? This book covers the entire four decades of Warhol's career, discussing the stages of his artistic development, and his contributions to art history.

[4]

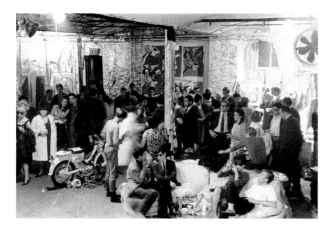

3
A party at the Factory, 1965

In approximately ten-year cycles, Warhol dramatically shifted his artistic direction. Beginning as a successful commercial illustrator in the 1950s, he reinvented himself as a hip cult figure in the 1960s. After a failed assassination attempt in 1968, Warhol became a fashionable society portraitist in the 1970s, before drawing together many of the techniques he had practised in an astounding tour de force of artistic innovation and productivity during his final decade. The sheer range and volume of his work is prodigious. At the core is Warhol's training in graphic design and illustration, which shaped his choice of subjects and the execution of his works. He continually experimented with new materials and techniques. Throughout Warhol's career we witness certain constants: his obsession with celebrity, beauty, glamour and wealth. Simultaneously, he knew the importance of politics and the finality of death, subjects that confront us with startling directness or lurk behind the glitter. Warhol understood these as the essential messages of his age and his art.

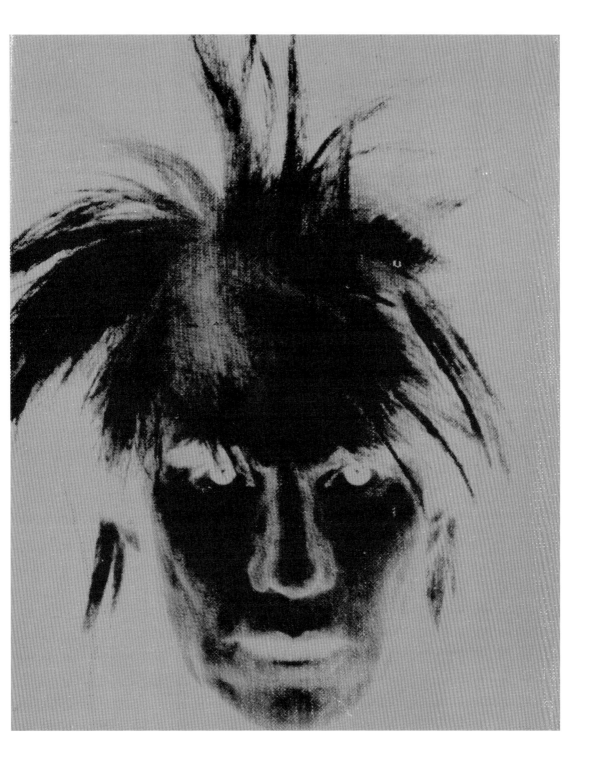

4
Self-Portrait, 1986
Synthetic polymer paint and silkscreen
ink on canvas
203.2 × 193 cm (80 × 76 in)
The Andy Warhol Foundation for
the Visual Arts, Inc.

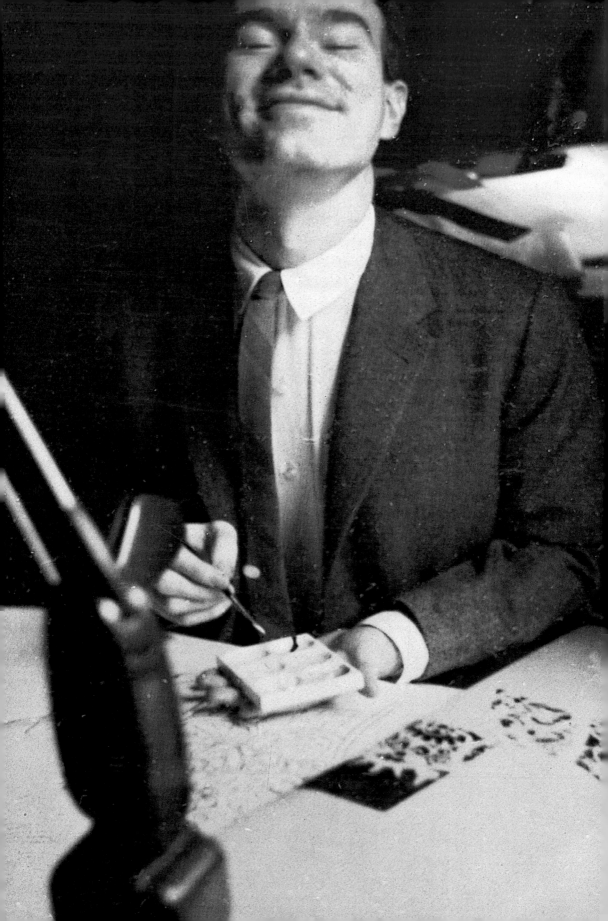

'SUCCESS IS A JOB IN NEW YORK'

AN EDUCATION

The graphic design and illustration training that Warhol received at the Carnegie Institute of Technology, in his home town of Pittsburgh, Pennsylvania, launched him on his path as an artist. Raised in an immigrant, working-class family during the Depression, Warhol was fortunate to have had this opportunity. Czech immigrants, Andrei and Julia Warhola, struggled to provide for their family in this difficult economic period. Andrei recognized that his youngest son, Andrew, had the talent to become the first family member to receive a college education, and he saved money to realize that ambition.

As a boy, Andrew Warhola suffered two severe bouts of rheumatic fever that forced him into convalescence at home with his mother. During the many months of recovery, Andrew drew avidly, and assisted his mother painting flowers on porcelain to supplement the family income. In these long, quiet hours he also cultivated what would become a lifelong obsession with celebrity, collecting signed photographs of movie stars, his most prized being a photograph of child actress Shirley Temple. Because of his considerable graphic ability, Warhol was recommended for the free Saturday art classes at the Carnegie Mellon Museum. There he blossomed under the tutelage of an enthusiastic teacher, who sparked his burgeoning interest in art and earned him a scholarship to Carnegie Tech.

Enrolled in the Pictorial Design programme, Warhol learned to draw like the leading illustrators of the day, the Regionalist painter Thomas Hart Benton

5
Warhol, aged eight, 1936

◄ Warhol working at home, 242 Lexington avenue, New York, 1957.

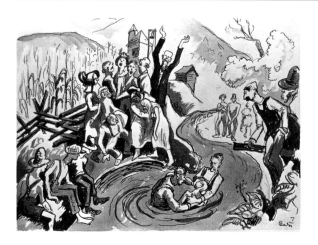

6
Thomas Hart Benton (1889–1975)
Baptism, 1926
Pen, black ink and brown wash
over graphite on paper
23.5 × 31 cm (9 ¼ × 12 ¼ in)
Princeton University Art Museum

and the expatriate German Expressionist George Grosz. In the summer of 1946, Andrew worked with his brother Paul, selling fruit and vegetables door-to-door in Pittsburgh from the back of a huckster wagon. He bought a sketchbook and with a vibrant, serpentine line drew the renewed vitality of post-war Pittsburgh pulling itself out of the Depression. The elongated figures in *Women and Produce Truck* have the same vibrancy of line that [10] is found in Benton's prints and Grosz's scenes of working class America. [6, 7] Unfortunately, Warhol struggled through school, facing academic expulsion on several occasions. During the first year at Carnegie his drawings and paintings did not stand out. One of his professors later admitted that, if he had been asked, Andrew Warhola would not have been a student 'most likely to succeed'. After his junior year Andrew faced dismissal from the school.

The faculty required him to attend summer school to improve his drawing. If he could submit an acceptable portfolio at the end of the session, he would be reinstated. The class transformed Warhol. The instructor Professor Russell Hyde challenged him to develop a personal style, to 'do it the way you see it'. As a fledgling artist entering school, he had cultivated the ability to render a likeness already seen in his earlier 1942 self-portrait. During his first years [9] at Carnegie Tech, his work acquired the sinewy line of his huckster truck drawings. Over the summer of 1948, he developed a broken-line style that he would master as a commercial artist. In his study of the outspoken Louisiana Senator Huey Long, Warhol exploits an array of dense ink lines off jagged [11] lines and energetic dashes to create a dynamic effect of figures densely compressed into a tight space. His draughtsmanship had become more stylized, with a range of markings that created a multifaceted surface texture and pattern, indicating his awareness of Ben Shahn, the principal American illus- [8] trator of the period, who had made the broken-line technique popular.

The graphic command that Warhol gained that summer impressed the faculty, who reinstated him into the programme, gave him an exhibition

and awarded him a $50 prize. The quiet Andrew Warhola became the popular Andy, bolstering his fragile self-esteem and initiating his artistic daring. His self-confidence grew with the encouragement of his friends, who were entertained by the drawings that Warhol dashed off to amuse them. Boosted by the faculty's response to his drawing and the popularity of his caricatures, Warhol became more daring. For his graduation exhibit, in May 1949, Warhol submitted *The Broad Gave Me My Face, But I Can Pick My Own Nose*. Despite the arguments for its inclusion by guest juror George Grosz, the other judges rejected the painting as obscene. Recognizing the publicity opportunity of his scandalous composition, Warhol exhibited it at a local gallery capitalizing on the picture's notoriety, a strategy that would serve him well in the future.

GLAMOUR ON MADISON AVENUE

Immediately after graduation in June 1949, Warhol and his close friend and classmate, Philip Pearlstein (b. 1924) – who would himself become an important figurative painter – moved to New York City. With his youthful ambition, Warhol aspired to be a famous and wealthy commercial artist. On his second day in the city he earned a commission from Tina Fredericks, artistic director of *Glamour* magazine, who admired his portfolio and asked what he could draw. He boasted, 'I can draw anything.' Fredericks gave Warhol his first commission to illustrate women's shoes. She loved them and then commissioned him to illustrate an article titled, 'Success is a Job in New York' (1949). The credit line for the drawings read, 'Andy Warhol', the magazine mistakenly dropping the final 'a' from his surname. Warhol liked the typo and kept the abbreviated surname as part of his new persona as a fashionable New York designer.

7
George Grosz (1893–1959)
Couple in New York, 1934
Watercolour on paper
64.1 × 45.1 cm (25 ¼ × 17 ¾ in)
Private collection

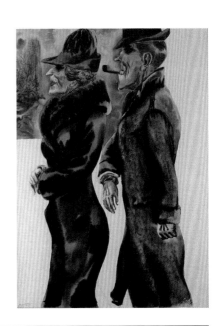

Fredericks's commission launched Warhol's career. Indeed, he became a 'success' over the next decade as the leading illustrator of women's clothing and shoes, earning him design awards, countless contracts and a handsome income. His drawings appeared in *Glamour*, *Harper's Bazaar*, *Ladies' Home Journal*, *McCall's* and *Vogue* magazines, and Warhol's work found its way into homes, grocery stores and dentist surgeries across the United States. The demand for his illustrations expanded to television, record covers, theatre posters and illustrated books.

[14]

SHOES AND CELEBRITIES

Warhol spent his days making the rounds with his portfolio, soliciting clients for commissions. He compulsively worked late into the night sketching his ad campaigns, leaving them for his assistants to reproduce using his signature blotted-line technique that he had learned at Carnegie Tech. His sketch for *Bird on Branch of Leaves* illustrates how the 'original' drawing is transferred onto another sheet, which Warhol's assistants would then hand-colour. [13] Graphic illustration was the vogue in the 1950s, and Warhol had perfected a quirky, distinctive touch that gave his images vibrancy. His popularity led him to win the contract to become the chief graphic designer for the I. Miller Shoe Company in 1955. In weekly ads in *The New York Times*, Warhol generated great demand for I. Miller's shoes with his elegant designs.

Warhol also sketched subjects of personal interest: literature, celebrities and young men. The 1950s witnessed the dawning of an openly homosexual culture in New York, to which Warhol was irresistibly attracted. While still a student, he had been captivated by Truman Capote's book *Other Voices, Other Rooms* (1948), an autobiographical account of a young man who, in search of his father, discovers his homosexuality. The subject struck a nerve with Warhol's

8
Ben Shahn (1898–1969)
Two Whispering Politicians, undated
Ink on paper
30.5 × 19.4 cm (12 × 7 ⅝ in)
The Phillips Collection, Washington, DC

own budding sexuality and he developed an obsession with Capote, producing portraits and self-portraits in the same likeness. Furthermore, his first professional art exhibition, in the summer of 1952 at Hugo Gallery in New York, was entitled 'Fifteen Drawings Based on the Writings of Truman Capote'. The show received a guarded review in *Art Digest* that described the work as precious and perverse. At this point the overt homosexual tone of the drawings clouded their reception by the art media. His private passion for drawing men culminated in 'Studies for a Boy Book', shown at the Bodley Gallery, which he blithely opened on Valentine's Day, 1956. Despite the public indifference to this show, several of the drawings were selected for a 'Recent Drawings' exhibition at The Museum of Modern Art, New York, later in 1956.

[15, 16]

[17]

Warhol's personal drawings attracted public attention later in 1956 when he combined his obsessions with shoes and celebrity in his 'Golden Slipper Show' at the Bodley Gallery during the Christmas holiday season. With the glamour of gold leaf and the delicacy of his line, his personifications of the famous through fantastic shoes were witty and beautiful. Their immense popularity resulted in commissions for shoe 'portraits' and a two-page spread in *Life* magazine (21 January 1957) championing his 'Crazy Golden Slippers'. Recognizing the popularity of celebrities, Warhol followed with his self-published *A Gold Book*, which features a pensive James Dean as the frontispiece. Warhol capitalized on the public's fascination with the actor and their instant recognition of his pose from Hollywood publicity stills, which he also included on the front cover.

[19]

[20]

[18]

A NEW GOAL

Warhol's career as an illustrator peaked in 1956–7. He won several awards from the Art Director's Club of America for his I. Miller ad campaigns. His personal drawings and books were widely distributed in magazines. Secure in his financial success, he purchased a townhouse on New York's fashionable Upper East Side and established Andy Warhol Enterprises, Inc. to manage his business affairs. Then, in 1958, just a year later, his business empire began to crumble. The fashion for hand-drawn illustrations began to wane. I. Miller cancelled its contract. Warhol scrambled for commissions to pay for his elaborate lifestyle. At the moment that his own success was beginning to slip, and his insecurity was increasing, Warhol witnessed a new paradigm of artistic success. Successive shows of the young painters Jasper Johns (b. 1930) and Robert Rauschenberg (1925–2008) in January and March 1958 at Leo Castelli Gallery, announced a significant shift in the art world away from the Abstract Expressionism of Pollock and Willem de Kooning (1904–1997). Their assemblages of everyday materials and subjects caused a sensation in the art world. Warhol admired their art and envied their success. Since his student days he had continually sought the new. He found it in Johns and Rauschenberg. Warhol became consumed with a new goal: to become a painter and to exhibit at Leo Castelli Gallery, a motivation that drove him on over the next decade.

◄ 9
Self-Portrait, 1942
Pencil on paper
48.3 × 34 cm (19 × 13 ⅜ in)
Private collection

10
Women and Produce Truck, 1946
Ink and graphite on paper
33 × 47.6 cm (13 × 18 ¾ in)
The Andy Warhol Museum, Pittsburgh

11
Untitled (Huey Long), 1948–9
Pen and ink on paper
73.7 × 58.4 cm (29 × 23 in)
Carnegie Museum of Art, Pittsburgh

12 ►
The Broad Gave Me My Face,
But I Can Pick My Own Nose, 1948–9
Tempera on Masonite
94 × 45.7 cm (37 × 18 in)
Private collection

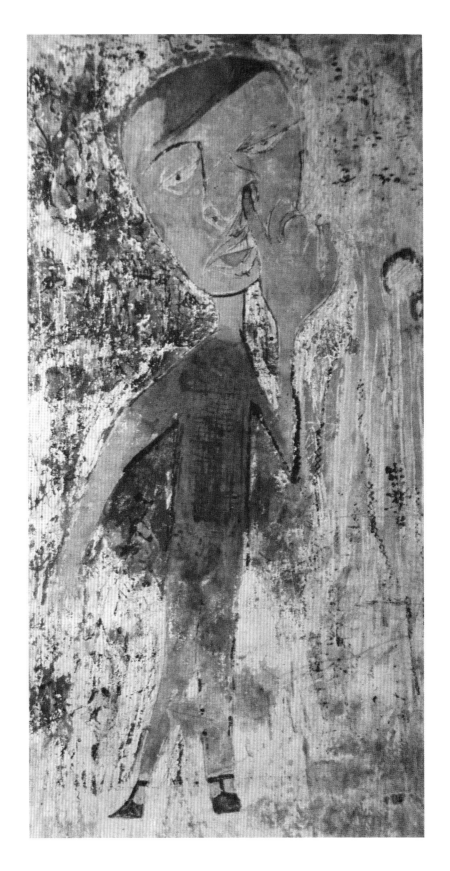

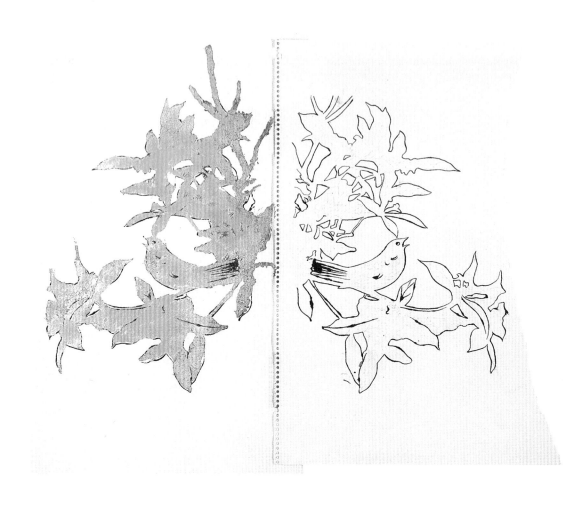

13
*Bird on Branch of Leaves, c.*1957
Gold leaf and ink on Strathmore paper
35.2 × 57.8 cm (13 ⅞ × 22 ¾ in)
Private collection

The key to Warhol's success as a graphic designer was his blotted-line drawing technique. The hatched, stippled lines of his illustrations gave the drawings a stylized, but dynamic surface quality. Line drawing was the vogue in illustration of the 1950s, and Warhol had perfected a quirky, distinctive line that brought the image to life. The technique was also the staple of his illustration business. Essentially a reproductive technique, he made the initial drawing on a sheet of water-resistant paper, which his assistants then wetted and transferred to other sheets and hand-coloured.

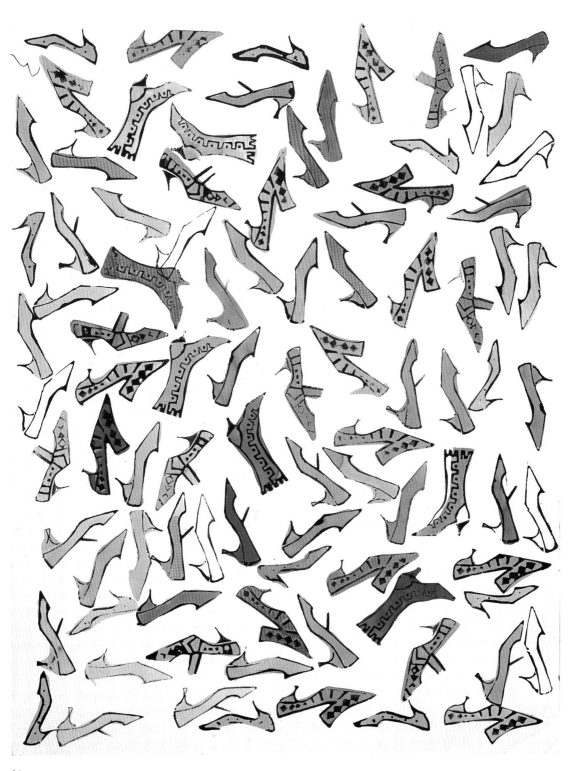

14
(Stamped) Shoes, 1950s
Ink and dye on paper
60.6 × 45.4 cm (23 ⅞ × 17 ⅞ in)
The Andy Warhol Museum, Pittsburgh

15
Truman Capote, c.1952
Ink on paper
42.5 × 34.9 cm (16 ¾ × 13 ¾ in)
The Andy Warhol Museum, Pittsburgh

16
Self-Portrait, c.1953
Ink on paper
27.9 × 21.6 cm (11 × 8 ½ in)
The Andy Warhol Museum, Pittsburgh

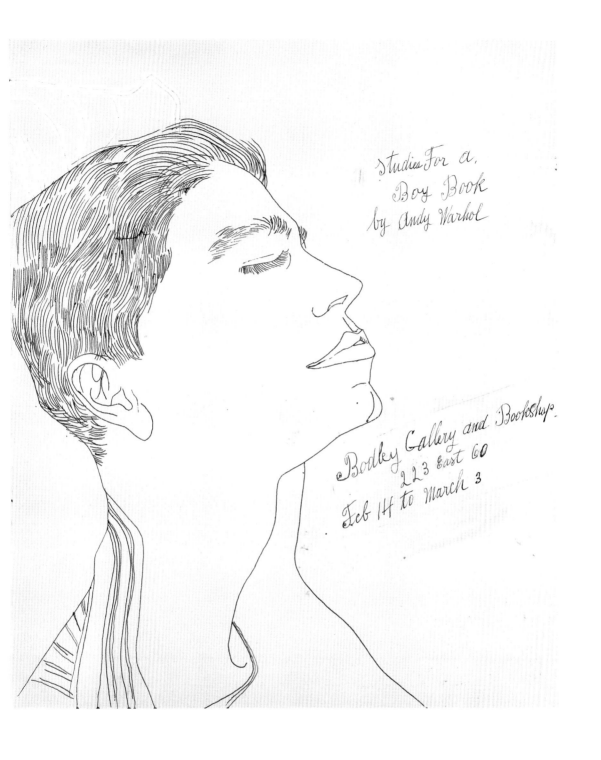

Studies For a
Boy Book
by Andy Warhol

Bodley Gallery and Bookshop.
223 East 60
Feb 14 to March 3

17
Studies for a Boy Book, 1956
Ballpoint pen and ink on paper
42.5 × 35.2 cm (16 ¾ × 13 ⅞ in)
The Andy Warhol Museum, Pittsburgh

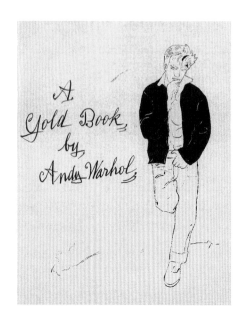

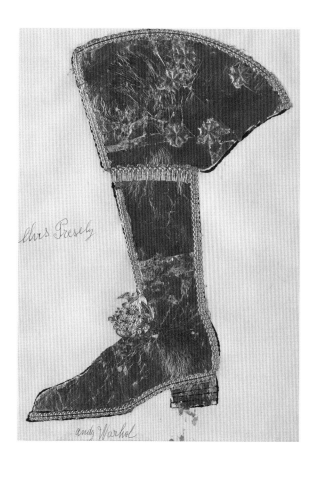

18
James Dean illustration for the front cover
of *A Gold Book*, 1957

19
Elvis Presley (Gold Boot), 1956
Ink, gold leaf and collage on paper
50.8 × 35.6 cm (20 × 14 in)
The Brant Foundation, Greenwich, CT

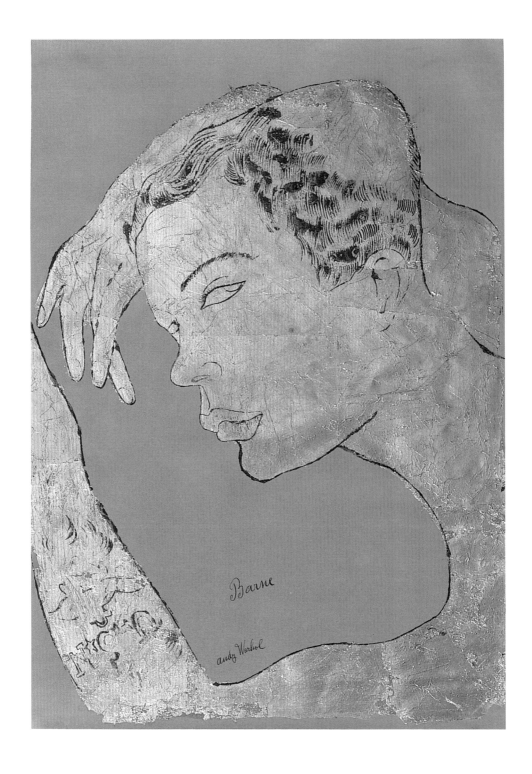

20
Barne, c.1957
Frontispiece for *A Gold Book*
Gold leaf and ink on paper
50.8 × 35.6 cm (20 × 14 in)
The Andy Warhol Museum, Pittsburgh

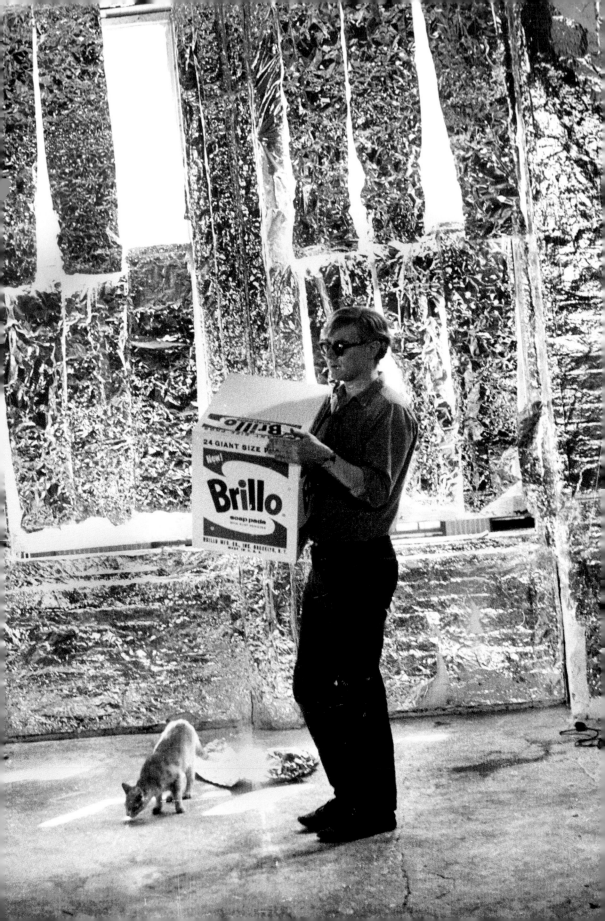

POP ANDY AND THE FACTORY

'WHAT DO WE DO NOW?'

In his article on 'The Legacy of Jackson Pollock' (1958), the artist Allan Kaprow (1927–2006) articulated the issues confronting his generation in the wake of the Abstract Expressionist's death in 1956. In his mind, Pollock had both liberated and killed art with his drip paintings. Kaprow asked, 'What do we do now?' Instead of painting sublime abstractions, he proposed that artists must pursue the opposite, a 'concrete art' of ordinary, everyday objects through which artists would divine the extraordinary. At this very moment, Leo Castelli Gallery hosted landmark shows for Johns and Rauschenberg consisting of commonplace signs, flags, newsprint, rags and old tyres that announced that the art world was changing. Warhol wanted to be part of it.

[21, 22]

Warhol continued to ply his commercial art trade, taking in commissions during the day, but now he began painting at night. His subjects and style began to shift, as can be seen in his drawings of brushes, palette knives, turpentine and enamel paint for *Glamour* magazine. The paintbrush is deftly drawn with a marvellous contrast between the assured outline of the handle – gained from a decade of experience – and the textures, twists and turns that delineate the bristles. Within the year he moved from the hardware shop to the magazine rack, and directly transcribed the front page of a sensationalizing tabloid with his ballpoint pen in a frightening premonition of Martin Luther King's assassination, 'Woman Stabs Rev. King in Harlem'. These daringly simple depictions of commercial products and newspapers are rendered with the emotionless objectivity that would characterize Pop Art, a dramatic departure from his delicate shoes and sensuous boy drawings. In these works we witness Warhol formulating his Pop Art iconography.

[29]

[30]

ADS AND ILLUSTRATIONS

Perusing the back pages of newspapers and magazines, Warhol had a stroke of inspiration and collaged a series of mundane ads for food, fitness and facial surgery into his first Pop Art painting, *Advertisement*. Warhol projected the ads onto a canvas and painted them in flat black silhouette against the bright white of the ground. Next, he isolated the individual ads and enlarged them. The stark contrast of the black on white heightened the visceral impact of such banal images. These are Warhol's first Pop Art paintings and they initiated an extraordinary period of artistic transformation over the next eight years, from the drips of these hand-painted works to his photo-transfer screenprints.

[31]

[32]

◄ Warhol carrying a *Brillo Box* at the Factory, 1964.

21
Jasper Johns (b.1930)
Flag, 1954–5
Encaustic, oil and collage on fabric,
mounted on plywood
107.3 × 153.8 cm (42 ¼ × 60 ⅝ in)
The Museum of Modern Art, New York

Eager to enter the New York art scene, Warhol asked his friends to introduce him to the important artists and dealers, primarily Castelli, Johns and Rauschenberg. While visiting the Castelli Gallery, its director Ivan Karp took Andy and his friend to the back room to show them a painting by a new artist, Roy Lichtenstein. Lichtenstein's painting of a comic strip surprised Warhol, who claimed that he was doing exactly the same thing. Karp visited his studio and recommended him to Castelli, but the gallery owner did not want to represent two artists doing similar subjects. Warhol later confessed that Lichtenstein was better at painting comics, so he explored other subjects. [23] [33]

Warhol got his first opportunity to show his paintings in April 1961, when Bonwit Teller department store invited him to decorate its display windows. He hung five canvases as a backdrop for women's fashions. Window displays provided many artists with exposure and, they hoped, an invitation to join a gallery. It disappointed Warhol that no gallery approached him after his presentation. His fragile ego required the validation of others, and he regularly solicited opinions of his work. He invited filmmaker Emile de Antonio to his studio and showed him two paintings of Coke bottles: one had expressive hatched marks and the other did not. In his emphatic manner, de Antonio told him, 'Andy, the abstract one is a piece of shit, the other one is remarkable. It's our society, it's who we are, it's absolutely beautiful and naked, and you ought to destroy the first one and show the other.' This response from de Antonio and others led the artist to abandon his drips and hatching for more evenly painted pictures that concealed his touch. [34] [35, 36]

USING MECHANICAL PRINTING PROCESSES

By the early 1960s many progressive artists had turned to a hard-edged style in both abstract and representational painting. Warhol also moved in this direction, using commercial design techniques to trace projections and to stencil in sections for an unmodulated surface. Choosing an item straight from the grocery shelf, which he claimed to have eaten for lunch every day for the previous twenty years, Warhol began a series featuring Campbell's

Soup cans. The simple subject of soup cans startled Los Angeles dealer Irving Blum, who offered to exhibit them at his Ferus Gallery that summer. Warhol expanded his collection of cans to include all thirty-two of Campbell's varieties. Upon the artist's request, Blum designed the display. Recognizing them as replicas of consumer commodities, Blum arranged the paintings on a shelf ringing the walls of his gallery, replicating the shelves of a grocery store. The artist loved the ingenious installation. The imposing directness and commanding frontality of the, seemingly, mechanically reproduced images challenged the public's conception of valid subjects for works of art.

▶ FOCUS (1) CAMPBELL'S SOUP CANS, P.60

Warhol moved steadily towards incorporating mechanical printing processes and diminishing the appearance of the artist's hand. While he was inquiring about ideas for his next paintings, someone asked Warhol, 'What is your favourite thing?' Without hesitation he answered, 'Money!' And he began rubber stamping, then silkscreening images of money. Working with a printer on these screen paintings, he learned how to transfer photographs to silk-screens. Instead of cutting screens to produce the image, Warhol exposed photographs onto screens treated with light-sensitive emulsions, then printed the photograph by using a squeegee to press the ink through the screen onto a canvas. That summer he created his first photo-transfer silkscreen painting, *Baseball*. This was a defining moment for Warhol. He recognized the potential of appropriating photographic images from mass market culture and utilizing commercial means to replicate them in order to reflect contemporary society, as if in a mirror.

[37]

22
Robert Rauschenberg (1925–2008)
Bed, 1955
Oil and pencil on pillow, quilt
and sheet on wooden supports
191.1 × 80 × 20.3 cm
(75 ¼ × 31 ½ × 8 in)
The Museum of Modern Art, New York

23
Roy Lichtenstein (1923–1997)
Popeye, 1961
Oil on canvas
106.7 × 142.2 cm (42 × 56 in)
Collection of David Lichtenstein

CELEBRITIES

Meanwhile, Marilyn Monroe had committed suicide in August 1962. Her death
provided Warhol with a sensational subject for his photo-transfer technique.
In Marilyn, Warhol found many of his cherished ideas of fame, beauty, glamour
and tragedy. He emblazoned Marilyn on a gold background idolizing her stature [60]
as he had done with his beautiful boy drawings of the 1950s and hearkening
back to the Byzantine icons of his Catholic youth. His obsession with Marilyn
resulted in his largest series to date, where he painted her in a variety of different
colours, black and white, singly, in serial images, and even isolating her [58]
sensuous lips into a frieze emblematic of the sex symbol. Having identified an [59]
ideal subject in celebrity, he expanded his scope to include Elizabeth Taylor, [49]
Elvis Presley, Natalie Wood and a host of stars of the silver screen.

► FOCUS ② MARILYN, P.66

FIRST EXHIBITIONS

The notoriety of the Soup Cans show in Los Angeles spread to New York. With
a vacancy in her schedule, Eleanor Ward, owner of New York's Stable Gallery,
agreed to exhibit Warhol's paintings in November 1962. That autumn Sidney
Janis Gallery, New York, introduced a new international trend in art, Pop Art,
in the infamous 'New Realists' exhibition, featuring Roy Lichtenstein, [23]
Claes Oldenburg (b. 1929), James Rosenquist and Warhol. In contrast to paint- [24]
erly Abstract Expressionism and the assemblage of Johns and Rauschenberg,
these artists carefully crafted and painted objects and images derived
from current popular culture: cars, comics and celebrities. Only a week later,
Warhol opened his solo exhibition at Ward's Stable Gallery, welcoming visitors
with his shimmering *Gold Marilyn Monroe* and presenting his hand-painted [60]
Dance Diagrams and *Coca-Cola* pictures, and also the photo-based works [38, 35, 36]
including *Baseball* and *Elvis*. The novelty of these exhibitions generated an [37, 41]
international sensation, earning Warhol considerable attention. Paradoxically,

the artist who had achieved extraordinary success for his hand-drawn illustrations in the 1950s would become the primary figure in the introduction of photo-mechanical imagery in art.

While at lunch in the summer of 1962, Warhol asked Henry Geldzahler, curator of Modern Art at The Metropolitan Museum of Art, for an idea for a painting. The curator threw the *New York Mirror* on the table and suggested that Warhol paint the headline, '129 Die in Jet!'. The riveting subject of disaster compelled Warhol to screenprint a series of suicides, car crashes and electric chair paintings later in 1963. The car crashes and electric chairs were brutal in their graphic rendering of the dark underside of celebrity, society and wealth, confronting the stark reality of death in America in contrast to his images of abundant commodities.

Capitalizing on Warhol's success in the autumn of 1962, Blum was eager to exhibit his paintings of Elvis at his Los Angeles gallery. The artist shipped Blum large bolts of silkscreened canvas with instructions for the dealer to cut and stretch the canvas to wrap the walls of the gallery. In Hollywood, the enveloping images of Elvis were an instant hit, particularly with young actors like Dennis Hopper, who hosted a party for the artist.

While in California, Warhol attended the opening of Marcel Duchamp's retrospective at the Pasadena Museum of Art, in order to meet the famous Dada artist. Although Warhol barely spoke to him, Duchamp's anti-modern art position propelled him to create a new body of work.

FACTORY WORK

To accommodate the increasing demand for his paintings, Warhol needed a larger studio. In January 1964 he purchased a former factory building on Union Square and hired Billy (Linich) Name to decorate the loft entirely in silver. The expanded facility dramatically increased Warhol's capacity to produce large-scale works and transformed his studio practice. The first pieces

[39]

[40]

[41]

[42]

24
James Rosenquist (b.1933)
Marilyn Monroe I, 1962
Oil and spray enamel on canvas
236.2 × 183.3 cm (93 × 72 ¼ in)
The Museum of Modern Art, New York

created at the Factory were his box sculptures. Lined up across the floor, Warhol instituted an assembly line production to build and then screen the boxes. The box sculptures originated with a case of *Campbell's Soup* that he made in 1962 and were reinforced by Duchamp's *Boîte-en-valise*, a box with reproductions of all of his art that had recently been re-editioned. Warhol installed his box sculptures at the Stable Gallery and at the Factory in 1964, filling the interior with faux cases of foodstuffs. The stacks rose to the ceiling, resembling the stockroom of a grocery store. The boxes replicated precisely the original product cartons, breeching the distinction between art and life. The traditional boundary between art and reality, from this point onwards, hovered in limbo. [46, 47] [25] [43]

FLOWERS

Warhol realized his artistic ambition in the autumn of 1964 when Leo Castelli offered him an exhibition. For this show he produced *Flowers*. Taking serial imagery to the extreme, Warhol created more variations in size and colour of *Flowers* than any other image in his entire career. The series was created from a photograph, taken by Patricia Caulfield, a commercial image that Warhol appropriated for his use. He darkened the background and highlighted the petals, pushing the image to abstraction. Balancing between decoration and abstraction, the *Flowers* series was immensely popular. The art dealer Ileana Sonnabend invited Warhol to show his *Flowers* in Paris in the following spring of 1965. The artist filled the Paris gallery with nearly 400 paintings and impressed the Parisians with a sensory overload experience. At the opening, he stunned the art world by announcing that he had 'retired' from art and planned 'to devote his life to the cinema'. [48]

INSTALLATIONS

At the height of his fame, Warhol walked offstage. Here he was emulating Duchamp, who announced in the 1920s that he had stopped painting to play chess. Warhol's supporters were not ready for him to quit. The Institute of Contemporary Art, Philadelphia, organized his first museum exhibition in

25
Marcel Duchamp (1887–1968),
Boîte-en-valise (series F), 1941–66
Valise containing miniature replicas,
photographs and colour reproductions
of works by Duchamp
overall: 40.7 × 38.1 × 10.2 cm
(16 × 15 × 4 in)
Portland Art Museum

26
Edie Sedgwick in 1965

October 1965. The opening was overwhelmed by thousands of boisterous supporters, forcing the staff to remove the paintings and the artist to slip out of the back door. His dealer was also not ready for Warhol to retire and Castelli arranged for an exhibition in the spring of 1966. For this show, Warhol expanded his work into new territory with an environmental, interactive installation, *Silver Clouds* and *Cow Wallpaper*. The playful wonder of the silver, helium-filled balloons and the decorative, pastoral cow wallpaper generated a festive atmosphere. The inflatable *Silver Clouds* were Warhol's 'invisible paintings', that reflected the participant and the room. With this project, he demonstrated that he had not retired but had moved from discreet objects hanging on the wall to a comprehensive, immersive experience, transforming the relationship between the viewer and the art object.

[44, 45]

FILMS

True to his Paris announcement, Warhol began to explore cinematography. It was a natural progression for him to move from still to moving images. In the summer of 1963, he bought a movie camera and began to experiment with filmmaking. Beginning by training the camera on his sleeping boyfriend John Giorno, then the Empire State building at night, his friends eating a pear and a prolonged kiss, Warhol reduced cinematic narrative to an experience as stationary as a skyscraper. By projecting his images in slow motion, he altered the experience of watching films, emphasizing the principal aspect of cinema: time. His films instantly became cult legends in underground film circles and within a year he earned the 'Independent Film Award' from *Film Culture*, the avant-garde film periodical edited by experimental filmmaker Jonas Mekas.

[62]
[63]

At the same time as Warhol purchased the Factory, he began making films. Along with the silver decor, Billy Name brought the New York subculture of the 1960s into the studio. Instantly the Factory became the site for aspiring artists, actors, musicians, druggies, gender benders and socialites enamoured of the edgy, bohemian lifestyle. Warhol conducted this menagerie of misfits

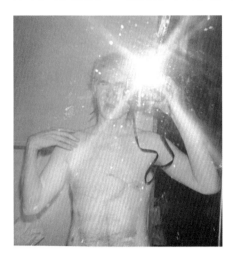

27
Warhol taking Polaroid pictures of
his wounds at Columbus hospital,
New York, 1968

in frenetic events consisting of music, film screenings, poetry readings
and impromptu performances that invariably evolved into all-night parties.
Chic New York mingled with bohemia at the Factory, where social norms
and taboos were left at the door and extravagant behaviour was welcome.
The Factory contained the cast of eccentric characters who would appear
in Warhol's films.

Warhol's camera focused on portraiture. Like his Pop paintings, his
films represented the people around him, some of whom he made into 'stars'.
In miles of *Screen Tests* he captured the likes of Dennis Hopper, Lou Reed,
Mick Jagger and his favourite star, Edie Sedgwick. Warhol idolized her as the
epitome of feminine beauty: tall, slender and boyish. Over the short duration
of one year Warhol made ten films with Edie, emphasizing her femininity and
fragile psyche.

► FOCUS (3) FILM, P.70

'EXPLODING PLASTIC INEVITABLE'

Continuing his exploration of pop culture, Warhol moved into music produc-
tion, managing the rock and roll band The Velvet Underground and designing
one of their album covers. Realizing the visceral impact of the late night,
multimedia Factory 'happenings', he wanted to expand this experience onto
a larger stage. His Factory friends found the band in an East Village club.
He contracted them to perform their music with a dizzying background
of slide projections, films, light shows, exotic dancers and performers that
he called the 'Exploding Plastic Inevitable'. Renting a club in downtown
Manhattan in 1966, The Velvet Underground and their chanteuse, Nico,
became a hit on the music circuit. Their success led them to tour the country,
transforming rock concerts into a multimedia experience.

[64]
[26]

[52]

[50, 51]

In his role as a Pop star, Warhol abandoned his friends from the commercial art world. This persona of the disengaged, apolitical and overtly 'swish' (his own words) public figure epitomized what Susan Sontag would coin as 'camp' in 1964. He adopted a new guise of the aloof voyeur dressed in black, coiffed with a silver wig. His Factory was the stage for 1960s decadence, with Velvet Underground rehearsals, film screenings, lines of aspiring superstars parading in and out, amphetamine junkies, transvestites and assorted fringe elements. On one occasion, a Factory acolyte shot a Marilyn painting that leaned against the wall. This lifestyle distanced Warhol from his former friends from the 1950s.

THE SHOOTING

Soon life would imitate art, violently, when disgruntled playwright Valerie Solanas walked into the Factory on 3 June 1968, pulled a gun out of a brown paper bag and shot Warhol. Rushed to hospital, Warhol later recalled, 'I was in surgery for about five hours ... They brought me back from the dead – literally, because I'm told that at one point I was gone. For days and days afterwards, I wasn't sure if I was back. I felt dead. I kept thinking, I'm really dead. This is what it's like to be dead – you think you're alive but you're dead.'

[27]

[28]

Despite his death-defying ordeal, Warhol did not lose his penchant for constructing a persona. A few months after his recovery he took polaroids of his wounds, was photographed by the fashion photographer Richard Avedon, and agreed to sit for portrait painter, Alice Neel, who depicted him as a wounded, fragile man. Ronnie Cutrone, Warhol's painting assistant, revealed, 'Andy prayed in the hospital promising God that, if he survived, he would attend mass every week.' In her sick publicity stunt to promote her film script, Valerie Solanas nearly killed Warhol and certainly brought to a crashing halt his Pop Art phase and the period of free love, sex and drugs at the silver Factory.

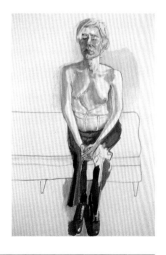

28
Alice Neel (1900–1984),
Andy Warhol, 1970
Oil on canvas
152.4 × 101.6 cm (60 × 40 in)
Whitney Museum of American Art,
New York

29
Hardware Item: Two Paintbrushes, 1958
Ink on Strathmore paper
28.6 × 23.5 cm (11 ¼ × 9 ¼ in)
The Andy Warhol Foundation for the
Visual Arts, Inc.

30
Journal American, c.1960
Ink on paper
60.3 × 45.4 cm (23 × 17 ⅞ in)
The Andy Warhol Museum, Pittsburgh

31
Advertisement, 1961
Water-based paint and wax crayon on canvas
177.2 × 133 cm (69 ¾ × 52 ⅜ in)
Staatliche Museen zu Berlin

32
Before and After [1], 1961
Casein on canvas
172.7 × 137.2 cm (68 × 54 in)
The Metropolitan Museum of Art, New York

33
Superman, 1961
Casein and wax crayon on canvas
170.2 × 132.1 cm (67 × 52 in)
Private collection

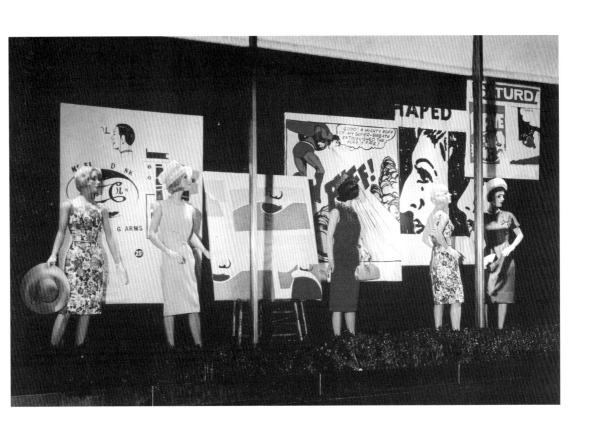

34
Five paintings by Warhol in a display
window at Bonwit Teller department store,
New York, April 1961

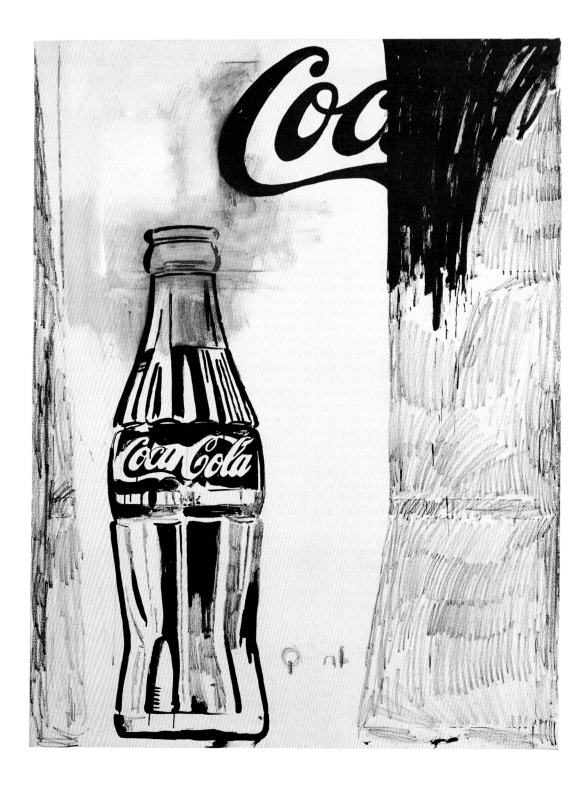

35
Coca-Cola [2], 1961
Casein and crayon on linen
176.5 × 132.7 cm (69 ½ × 52 ¼ in)
The Andy Warhol Museum, Pittsburgh

36
Coca-Cola [3], 1962
Casein on cotton
176.5 × 132.7 cm (69 ½ × 52 ¼ in)
The Mugrabi Collection, New York

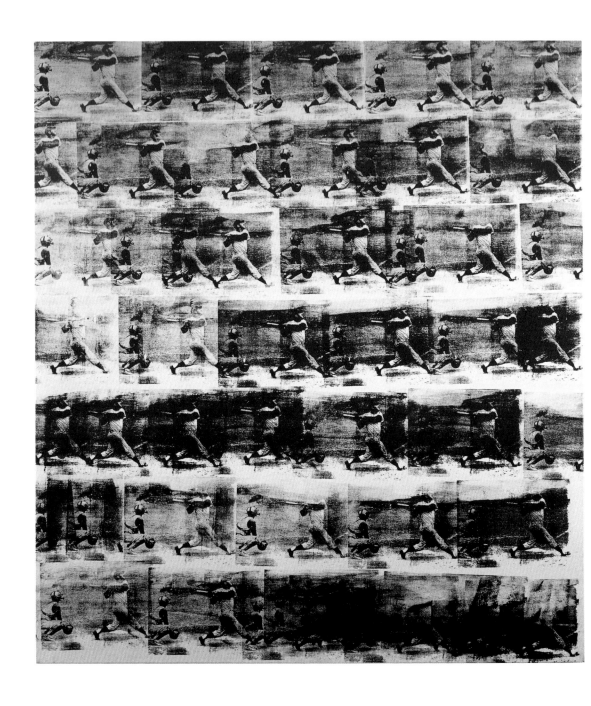

37
Baseball, 1962
Silkscreen ink on linen
233 × 208.3 cm (91 ¾ × 82 in)
Nelson-Atkins Museum of Art, Kansas City

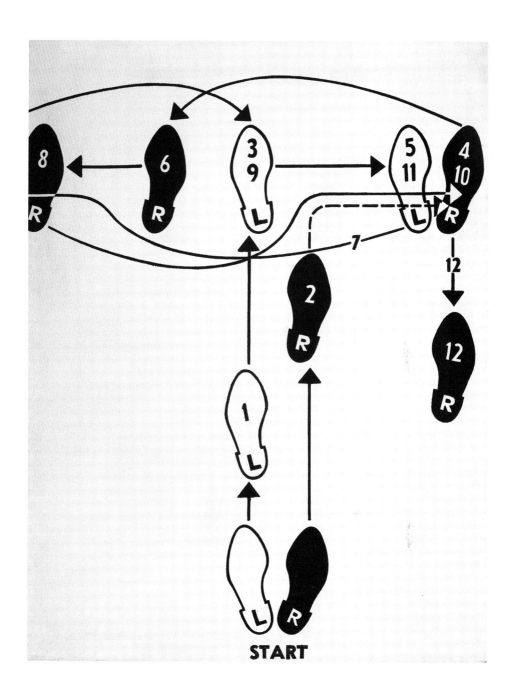

38
Dance Diagram [1], 1962
Casein and pencil on linen
183.5 × 137.8 cm (72 ¼ × 54 ¼ in)
Museum für Moderne Kunst, Frankfurt am Main

39
129 Die in Jet!, 1962
Acrylic and pencil on linen
254 × 182.9 cm (100 × 72 in)
Museum Ludwig, Cologne

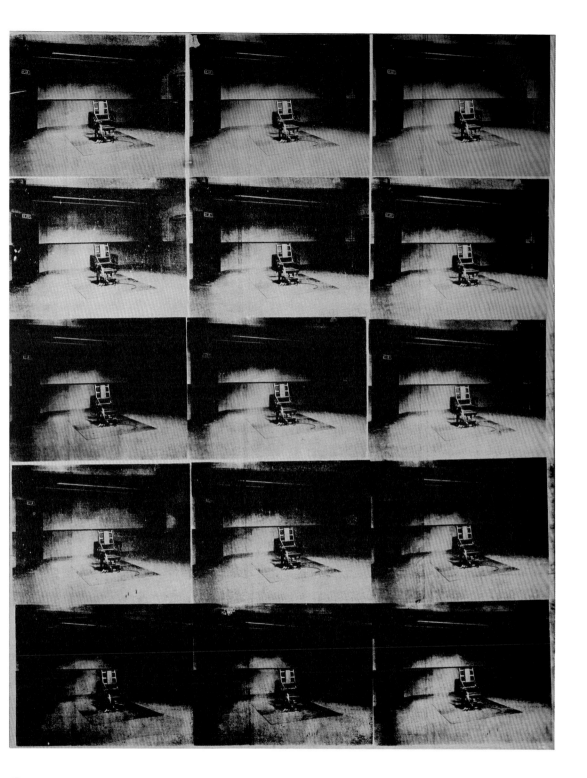

40
Lavender Disaster, 1963
Acrylic, silkscreen ink and pencil on linen
269.2 × 208.3 cm (106 × 82 in)
The Menil Collection, Houston

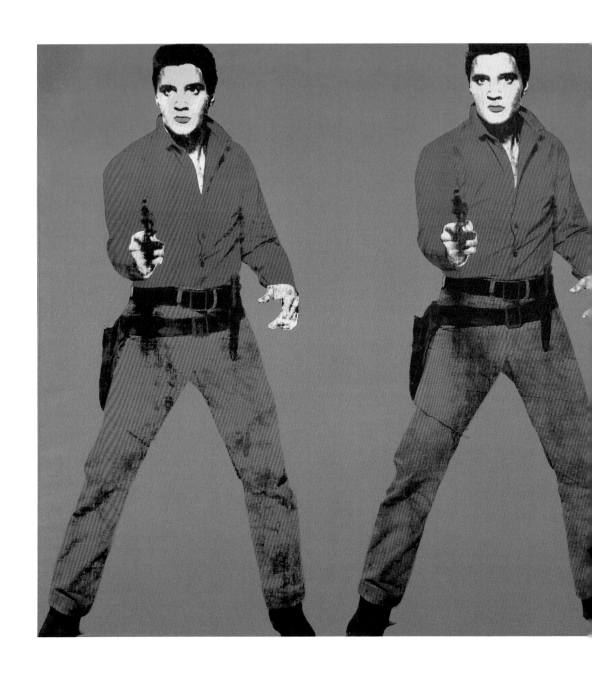

41
Elvis Diptych I and II, 1963 (silver canvas)
1964 (blue canvas)
Silkscreen ink and spray paint on linen
(silver canvas); silkscreen ink and acrylic
on linen (blue canvas)
208.3 × 208.3 cm (82 × 82 in) each
Art Gallery of Ontario

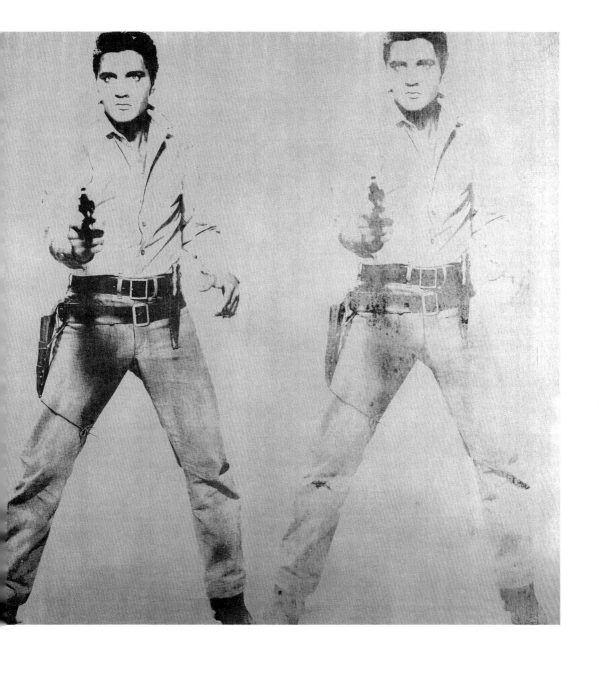

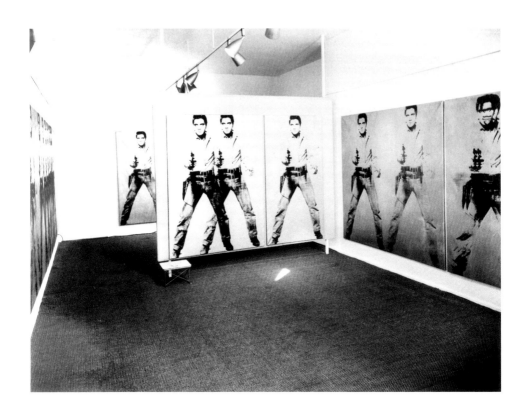

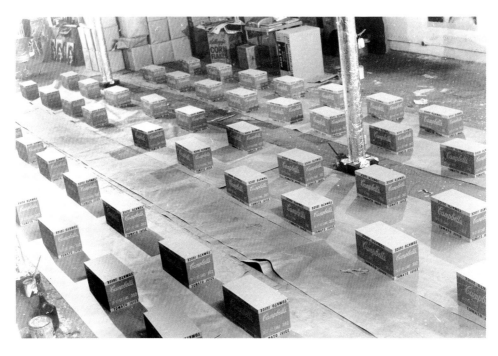

42
Elvis installation at Ferus Gallery,
Los Angeles, 1963

43
Campbell's Tomato Juice Box
sculptures at the Factory, 1964

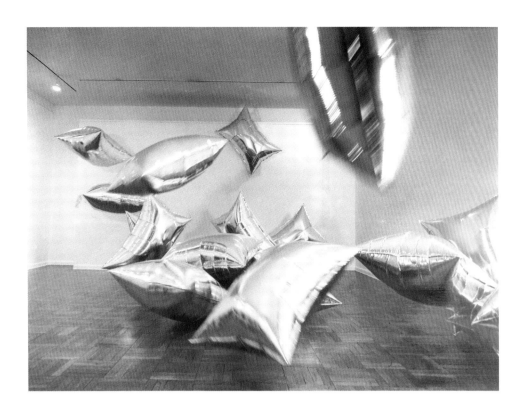

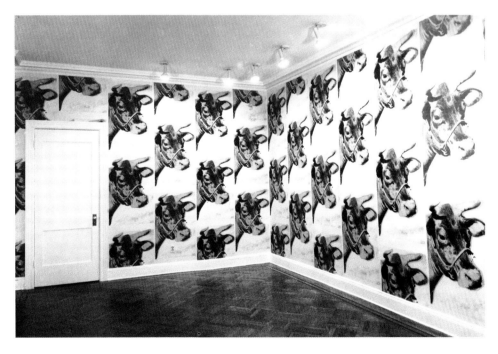

44
Silver Clouds at Leo Castelli Gallery,
New York, 1966

45
Cow Wallpaper at Leo Castelli Gallery,
New York, 1966

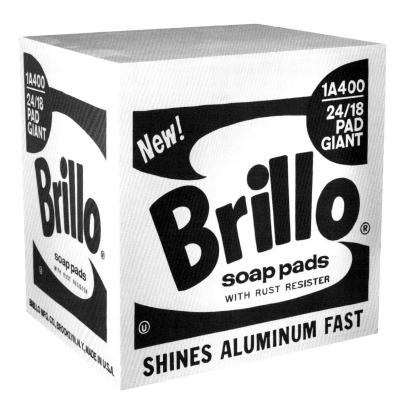

46
Brillo Soap Pads Box (Stockholm Type), 1964
Silkscreen ink and house paint on plywood
43.5 × 43.5 × 35.6 cm (17 ⅛ × 17 ⅛ × 14 in)
Private collection

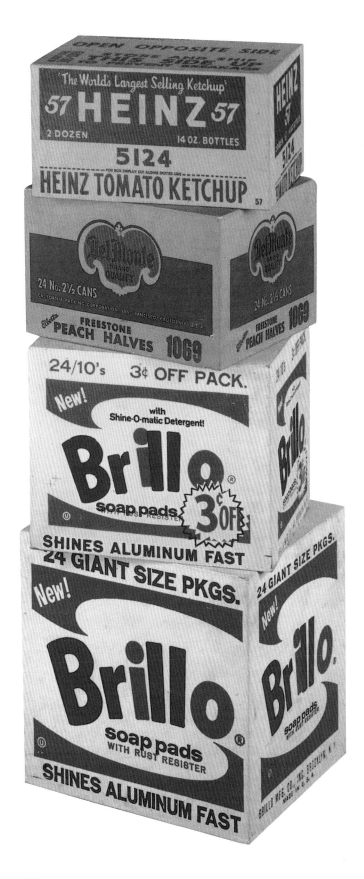

47
Stack of *Heinz, Del Monte* and
Brillo Boxes, 1964

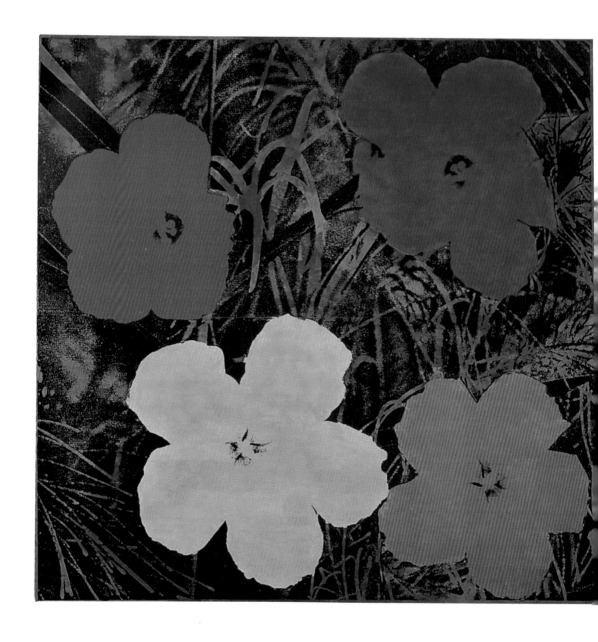

48
Flowers, 1964
Acrylic, silkscreen ink and pencil on linen
206.7 × 207.6 cm (81 ¾ × 81 ¾ in)
The Andy Warhol Museum, Pittsburgh

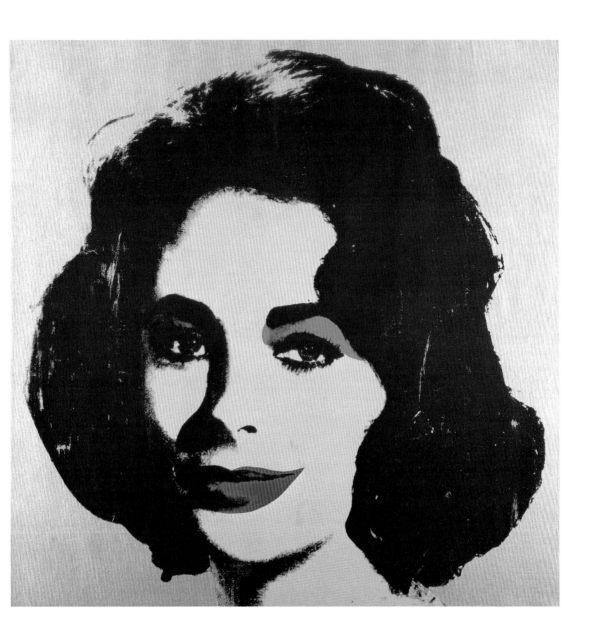

49
Silver Liz, 1963
Silkcreen ink, acrylic and spray
paint on canvas
101.6 × 101.6 cm (40 × 40 in)
Private collection

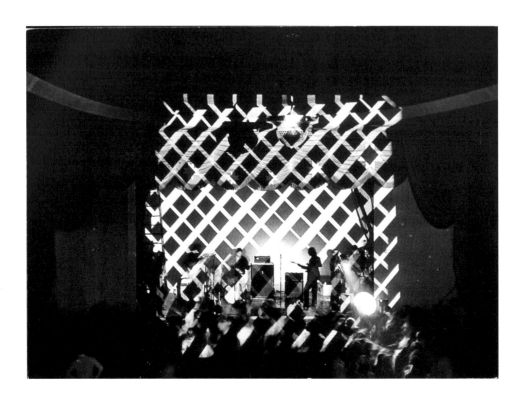

50, 51
Patterns and images projected on stage
during the 'Exploding Plastic Inevitable'
performance with The Velvet Underground
and Nico at the Dom nightclub in New
York, 1966

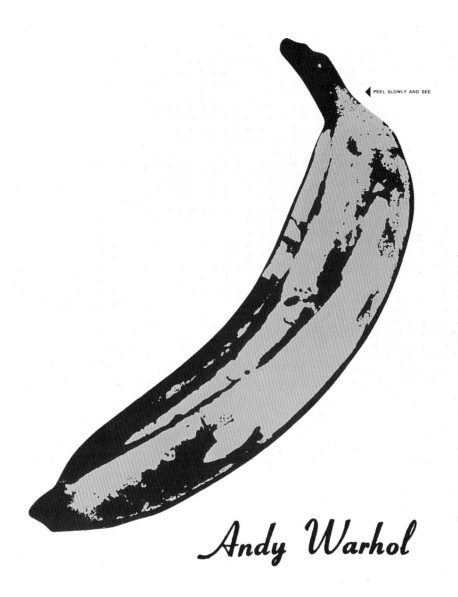

PEEL SLOWLY AND SEE

Andy Warhol

52
Album cover design (1967) for the debut
album of The Velvet Underground & Nico,
which features a yellow banana sticker that
can be 'unpeeled' to reveal a pink banana.

FOCUS ①

CAMPBELL'S SOUP CANS

Reflecting on his career, Warhol claimed that the *Campbell's Soup Can* was his favourite work [53] and that, 'I should have just done the *Campbell's Soups* and kept on doing them ... because everybody only does one painting anyway.' Certainly, it is the signature image of the artist's career and a key transitional work from his hand-painted to photo-transferred paintings. Created during the year that Pop Art emerged as the major new artistic movement, two of his soup can paintings were included in the landmark Sidney Janis Gallery exhibition, 'The New Realists'.

In the spring of 1962, Warhol had been working on his new renditions of ads and comic strips when he saw Roy Lichtenstein's comic-strip paintings at Leo Castelli Gallery. Soliciting suggestions for subjects to paint, he asked a friend, who suggested he choose something that everybody recognized like Campbell's Soup. In a flash of inspiration he bought cans from the store and began to trace projections onto canvas, tightly painting within the outlines to resemble the appearance of the original offset lithograph labels. Instead of the dripping paint in his previous ads and comics, here Warhol sought the precision of mechanical reproduction.

At this time he received a return studio visit from Irving Blum of Ferus Gallery, Los Angeles, who was expecting to see comic-strip paintings and was surprised by the new soup cans, immediately offering the artist a show that summer. Expanding his subject, he decided to paint one of each of the thirty-two varieties of Campbell's soups [54]. Blum exhibited the cans on shelves running the length of his gallery [55]. The exhibition caused a mild sensation in Los Angeles. The more daring members of the youthful art and film community were intrigued by their novelty. Most people, however, treated them with indifference or outright disdain. A nearby art dealer parodied the show by displaying a stack of soup cans, advertising that you could get them cheaper in his gallery. Blum had sold five of the paintings before he recognized that the group functioned best as a single work of art. He bought back the works already purchased, including one from Dennis Hopper, then offered to buy the set from Warhol in instalments for the modest sum of $3,000.

With his *Campbell's Soup Cans* installation at Ferus Gallery, the artist realized the possibility of creating works in series, and the visual effect of serial imagery. He continued making variations on his *Soup Cans*, stencilling multiple cans within a single canvas and so amplifying the effect of products stacked in a grocery store, an idea that he would later develop in the box sculptures [56]. He also realized that the serial repetition of an image drained it of its meaning, an interesting phenomenon most poignantly presented in his *Disasters* [40], in which the constant exposure to their graphic displays of violence numbs the senses. And, perhaps the most significant outcome of this series was the artist's push towards printing to achieve the mechanical appearance that he sought in his paintings.

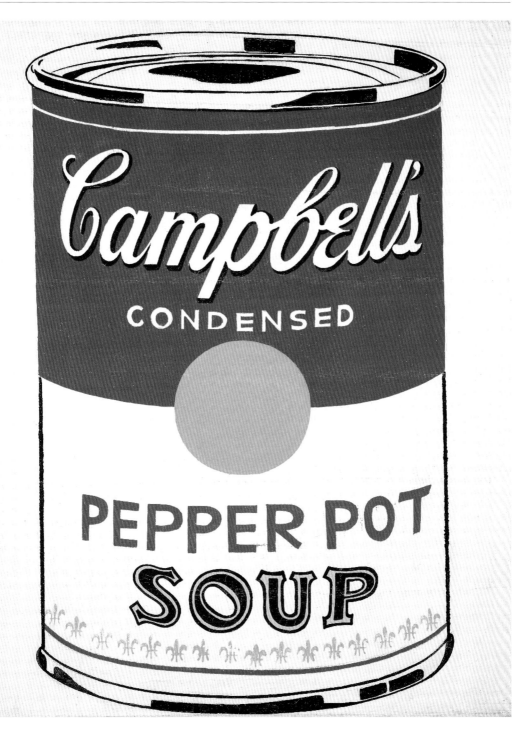

53
Campbell's Soup Can (Pepper Pot), 1962
Casein and pencil on linen
50.8 × 40.6 cm (20 × 16 in)
Private collection

 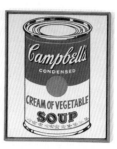 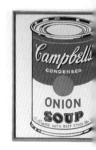

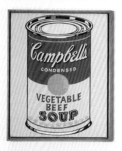 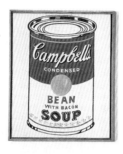 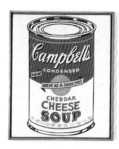 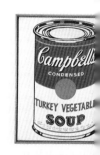

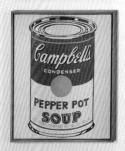 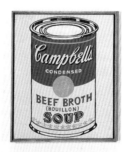 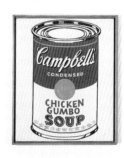 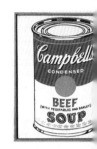

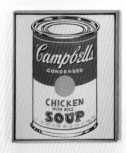 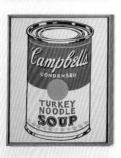 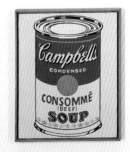 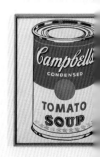

54
32 Campbell's Soup Cans, 1962
Casein, metallic paint and pencil on linen
50.8 × 40.6 cm (20 × 16 in) each
The Museum of Modern Art, New York

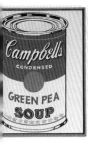

GREEN PEA
SOUP

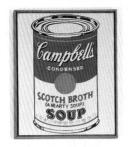

SCOTCH BROTH
(A HEARTY SOUP)
SOUP

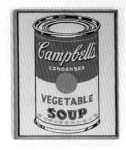

VEGETABLE
SOUP

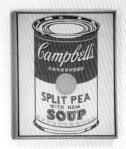

SPLIT PEA
WITH HAM
SOUP

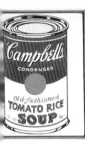

Old-fashioned
TOMATO RICE
SOUP

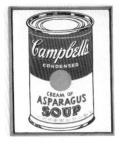

CREAM OF
ASPARAGUS
SOUP

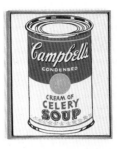

CREAM OF
CELERY
SOUP

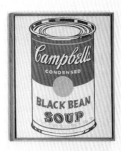

BLACK BEAN
SOUP

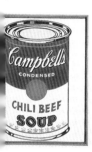

CHILI BEEF
SOUP

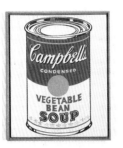

VEGETABLE
BEAN
SOUP

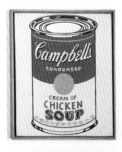

CREAM OF
CHICKEN
SOUP

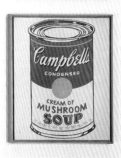

CREAM OF
MUSHROOM
SOUP

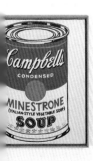

MINESTRONE
(ITALIAN-STYLE VEGETABLE SOUP)
SOUP

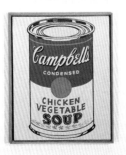

CHICKEN
VEGETABLE
SOUP

BEEF
NOODLE
SOUP

VEGETARIAN
VEGETABLE
SOUP

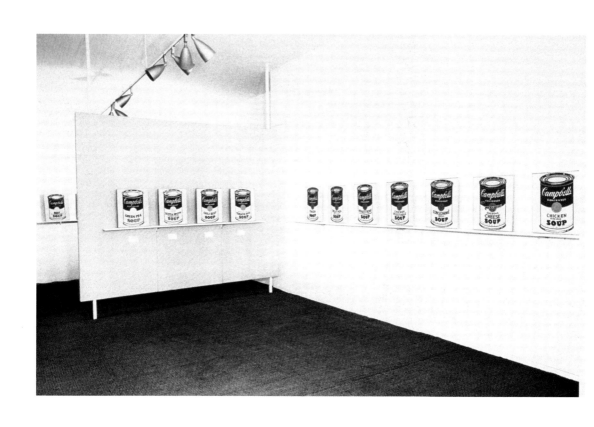

55
Installation view of 'Campbell's Soup Cans'
exhibition at Ferus Gallery, Los Angeles, 1962

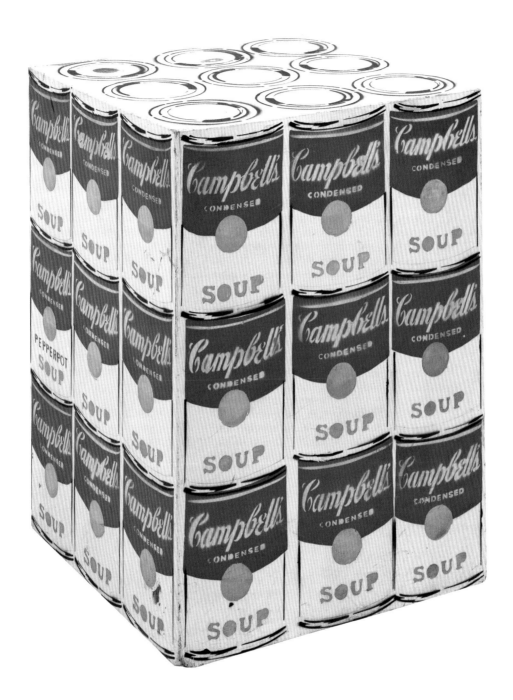

56
Campbell's Soup Box, 1962
Casein, spray paint and pencil on plywood
55.9 × 40 × 40 cm (22 × 15 ¾ × 15 ¾ in)
The Andy Warhol Museum, Pittsburgh

FOCUS (2)

MARILYN

While *Campbell's Soup Can* may be Warhol's signature image, his *Marilyn* paintings [57] epitomize his obsession with celebrity, beauty and death. Beginning with the soup cans, the artist edged increasingly closer to commercial printing. Seeking to replicate the appearance of commercial products in his paintings, Warhol pushed his exploration of reproductive techniques to include rubber stamps, stencils and silkscreens. During the summer of 1962, he learned from his printer about the photo-transfer silkscreen. Returning to his childhood fascination with celebrity photos and his commercial art technique of using photo cuttings, he began his experiments in photo-transfer silkscreening with images of movie stars. At that moment, on 5 August 1962, Marilyn Monroe committed suicide. Recognizing the confluence of celebrity and tragedy in this unique event, Warhol embarked on his largest series so far, creating creating literally thousands of paintings and prints of Marilyn [58], that would establish his critical and popular success as an artist.

Warhol had now found the medium that best suited his ambition to mirror mass culture icons and products, and he moved into two signature bodies of work: the disasters and the celebrities. Both of these subjects were realized in the portraits of Marilyn. Warhol had assembled a huge collection of publicity photos of the silver screen sex symbol, selecting one as the source material for his silkscreens. In this series the artist developed the silkscreen process that he would perfect over the ensuing decades. Contrary to expectations, Warhol would paint the canvas in a variety of colours and then screen the image of Marilyn on top. The misregistration of the painting and the screenprint created a dynamic surface that he enhanced with a broad, spectrum of colours. The act of printing and painting in multiple variations shows Warhol playing with typical commercial art processes in order to explore the range of graphic possibilities in an image. In his canvases of Marilyn, Warhol demonstrated his extraordinary sense of colour, introducing metallic paints and day-glow colours, and beginning to explore the brilliant colours that would electrify his subsequent Pop paintings. But more significantly, with Marilyn he co-opted the photographic means of mass communication and captured the public gaze with an icon of contemporary culture that appealed to our most base emotions: fame, lust and sense of mortality. By isolating her sensuous lips into a frieze [59], he crystallized her sex symbol appeal.

Marilyn was the centrepiece of Warhol's solo exhibition at the Stable Gallery in November 1962. *Gold Marilyn Monroe* [60], a memorial to the recently deceased celebrity, greeted visitors at the entrance to the show. On the heels of 'The New Realists' exhibition that had opened one week earlier, this show was an instant hit and *Marilyn* was the leading star. The architect Philip Johnson bought the painting and donated it to The Museum of Modern Art, New York, launching Warhol on a successful career as an artist. It has also been argued that Warhol crafted Marilyn into an idol. At this point in her film career, she was a fading star. The popularity and proliferation of Warhol's image of Marilyn revived her reputation as well as assuring the ascendancy of Warhol as a Pop star.

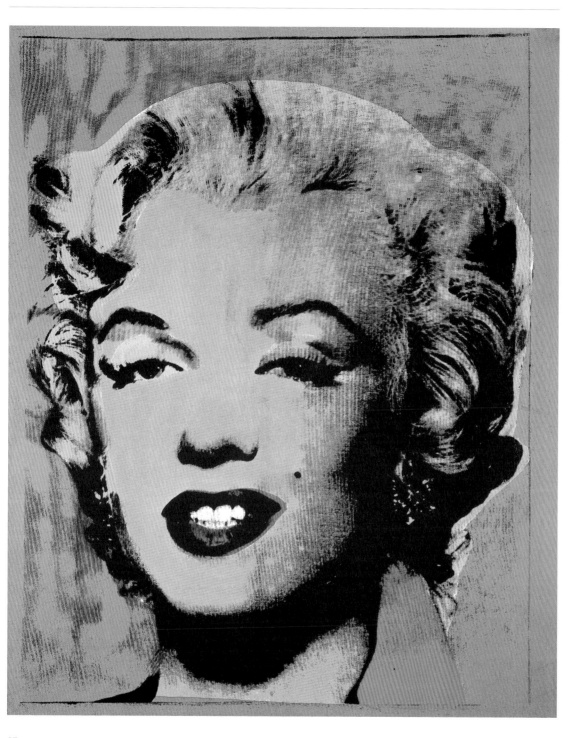

57
Blue Marilyn, 1962
Acrylic and silkscreen ink on linen
50.8 × 40.6 cm (20 × 16 in)
Princeton University Art Museum

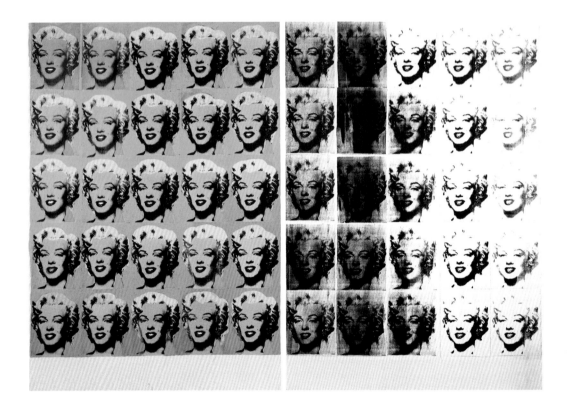

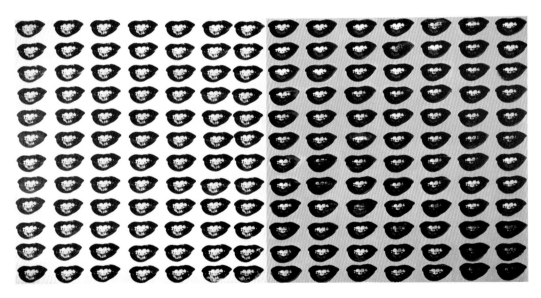

58
Marilyn Diptych, 1962
Acrylic, silkscreen ink and pencil
on linen
205.7 × 144.8 cm (81 × 57 in)
Tate, London

59
Marilyn's Lips, 1962
Acrylic, silkscreen ink and pencil on linen
Black-and-white canvas: 210.2 × 209.2 cm
(82 ¾ × 82 ⅜ in); canvas in colour:
210.2 × 205.1 cm (82 ¾ × 80 ¾ in)
Hirshhorn Museum and Sculpture Garden,
Smithsonian Institution, Washington, DC

60 ►
Gold Marilyn Monroe, 1962
Acrylic, silkscreen ink, gold paint
and spray paint on linen
211.5 × 144.8 cm (83 ¼ × 57 in)
The Museum of Modern Art, New York

The late 1950s and 1960s witnessed the growth of an underground film movement in the United States centred around the Filmmakers' Cooperative in New York, organized by Stan Brakhage, Gregory Markopolous and Jonas Mekas. These independent filmmakers were rebelling against Hollywood's entertainment industry and wanted to establish the medium of film as an art form. Warhol actively attended screenings of avant-garde films at the Cooperative's Cinematheque, stoking his interest in cinema. In 1963 he began to make films [61].

His first experiment with this new medium was to film his boyfriend sleeping [62]. Fixing the camera on its tripod, Warhol trained the lens across the sleeping man's body. Slowing down the projection from the standard 24 frames per seconds to 16, the edited footage results in a five-and-a-half hour film that presents the still, silent gaze of a voyeur. He also used this technique with *Empire* [63]. For six hours he filmed the iconic skyscraper as the evening turned to night and the building gradually disappeared into the darkness. Projected at 16 frames per seconds, the film lasts eight hours and becomes, initially, an endurance test, taxing the patience of the viewer. The essence of the cinematic experience is time. In *Sleep*, *Empire* and other early films, Warhol suspends our normal sense of time. By slowing time down to an almost static experience, he creates a transcendent, meditative experience.

Warhol's filmmaking was radical in its reduction of the medium to its fundamental properties: a stationary camera with no pretensions to narrative or action. The effect is remarkably similar to that of his Pop paintings, especially the silver paintings that he produced at the same time. The installation of his silver *Elvis* paintings at Ferus Gallery in 1963 demonstrates how the multiples of Elvis [42], filling the frame on a silver ground, resemble the frames of a film projected across the wall. In the protracted stasis of *Sleep* and *Empire*, the 'motion picture' is practically reduced to an 'immobile image'.

Warhol radically altered the landscape of independent film and spawned a new genre of film, later called Structuralist film, in which the basic properties of the camera and the film become the subject. The novelty of *Empire* moved the Filmmakers' Cooperative to award Warhol the Independent Film Award in 1964. Within a single year of picking up a movie camera, Warhol had reached the pinnacle of avant-garde film.

The principal focus of Warhol's camera lens was portraiture, especially evident in his *Screen Tests*. Between 1963 and 1966, he shot over 500 *Screen Tests*, each following the same formula: the sitter remains emotionless before the stationary camera for the entire length of the $30\frac{1}{2}$-metre (100-foot) film. These were not Hollywood screen tests intended to assess the photogenic qualities of potential actors. Warhol wanted to 'catch people being themselves. It's better to act naturally than to set up a scene and act like someone else. You get a better picture of people being themselves instead of trying to act like they're themselves.' Many of the hundreds of people that he filmed – including superstar 'Baby Jane' Holzer, actor Dennis Hopper or the photographer Billy Name [64] – strained to maintain an unemotional countenance. In one rare *Screen Test*, as poet Ann Buchanan strains to avoid blinking, tears begin to rain down her cheek, revealing raw emotion.

Warhol had a keen eye for selecting ideal cinematic faces from the crowds that filled his Factory. His favourite was Edie Sedgwick. He adored Edie's

feminine yet androgynous beauty, elevating her into his first superstar, and featuring her in ten films over the course of a year. She became the Marilyn Monroe of his film work, both sex symbol and tragic figure. He cast Sedgwick in one of his more innovative films, *Outer and Inner Space* [65], which he expanded to two screens, capturing Edie in conversation while a video of her played on a television monitor. The two screens create a film within a film edited into a complex interplay of cinematic space and dialogue. Over the year, Edie grew paranoid that Andy had exploited her for her beauty and wealth. After an argument in early 1966, she abruptly left the Factory, dying a few years later of a drug overdose.

From his early silent, Structuralist films, Warhol's work evolved into more complex narrative productions. *Chelsea Girls* [66] was his first commercial success. Again using a double screen projection, Warhol edited a series of takes in which Factory characters act out unscripted dialogues in various rooms of the Chelsea Hotel. Projected in cacophonous pairs, the emotional swings and schizophrenic conversations – often fuelled by amphetamines – created a *mélange* of sixties subculture that became a cult movie on the underground film circuit. After the box office success of this film, he expanded his cinematic ambitions with *Lonesome Cowboys* [67], filmed in Arizona with a full production company, a homoerotic parody of Hollywood westerns that earned Warhol considerable attention in cult film circles and paved the way for future parodies such as Mel Brooks's *Blazing Saddles* (1974).

After recovering from his gunshot wounds, Warhol directed only one other film, *Blue Movie* (1968). He pulled his early underground films out of circulation in around 1970, so that his films of the 1960s were not seen again until after his death. He turned over the filmmaking enterprise to Paul Morrissey, a Film Factory regular, who continued the cinematic narrative path of Warhol's last films, directing such films as *Andy Warhol's Dracula* and *Andy Warhol's Frankenstein* (both 1973). But over the decade Warhol Enterprises' investment in cinema decreased and finally ended with *Andy Warhol's Bad* (1976). Taking a cue from his own remark in the 1960s, 'I believe in television. It's going to take over from movies,' Warhol began to focus on commercial broadcast television. His series *Fashion* (1980–2), *Andy Warhol's TV* (1980–3) and *Andy Warhol's Fifteen Minutes* (1985–7) were televised extensions of the celebrity and star format of *Interview* magazine and marked his transformation from avant-garde filmmaker to TV celebrity.

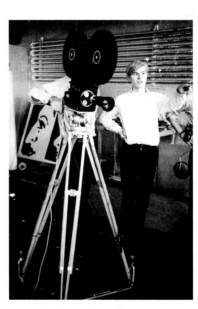

61
Warhol directing a film at the Factory, 1965.

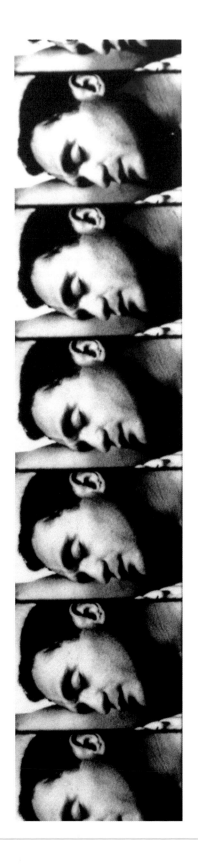

62
Stills from *Sleep*, 1963
Film, 16mm, black and white, silent,
5 hours and 21 minutes
The Andy Warhol Museum, Pittsburgh

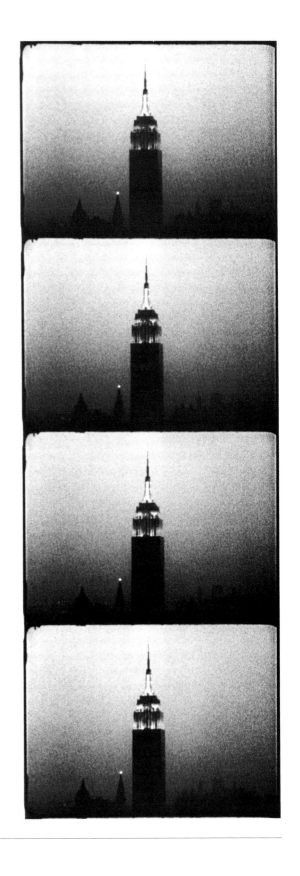

63
Stills from *Empire*, 1964
Film, 16mm, black and white, silent,
8 hours and 5 ½ minutes
The Andy Warhol Museum, Pittsburgh

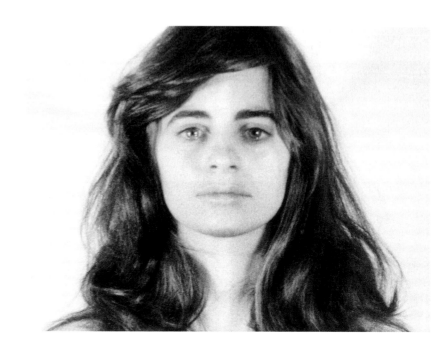

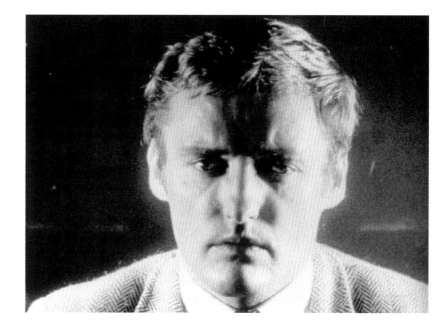

64
Screen Tests, c.1963–6
16mm, black and white, silent, each
approx. 4 minutes at 16 frames per second
(clockwise from top): *Ann Buchanan, 'Baby
Jane' Holzer, Billy Name, Dennis Hopper*
The Andy Warhol Museum, Pittsburgh

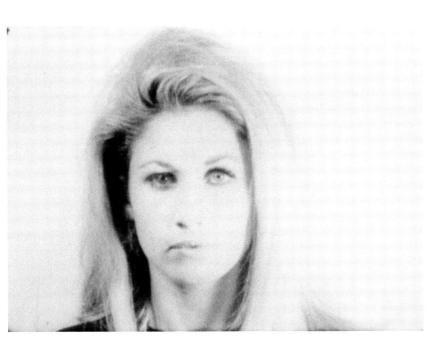

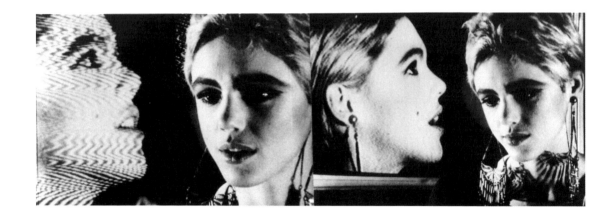

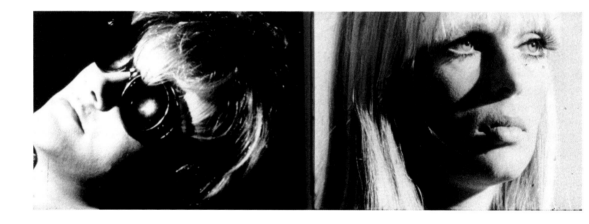

65
Stills from *Outer and Inner Space*, 1965
Film, 16mm, black and white, sound,
1 hour and 6 minutes on double screen
The Andy Warhol Museum, Pittsburgh

This split-screen projection shows
Edie Sedgwick watching herself on
a television screen and commenting
on her own performance.

66
Stills from *Chelsea Girls*, 1966
Film, 16mm, black and white and colour,
sound, 3 hours and 24 minutes on double
screen, with Ingrid Superstar and Nico
The Andy Warhol Museum, Pittsburgh

67
Stills from *Lonesome Cowboys*, 1967–8
Film, colour, sound, 1 hour and 39 minutes
The Andy Warhol Museum, Pittsburgh

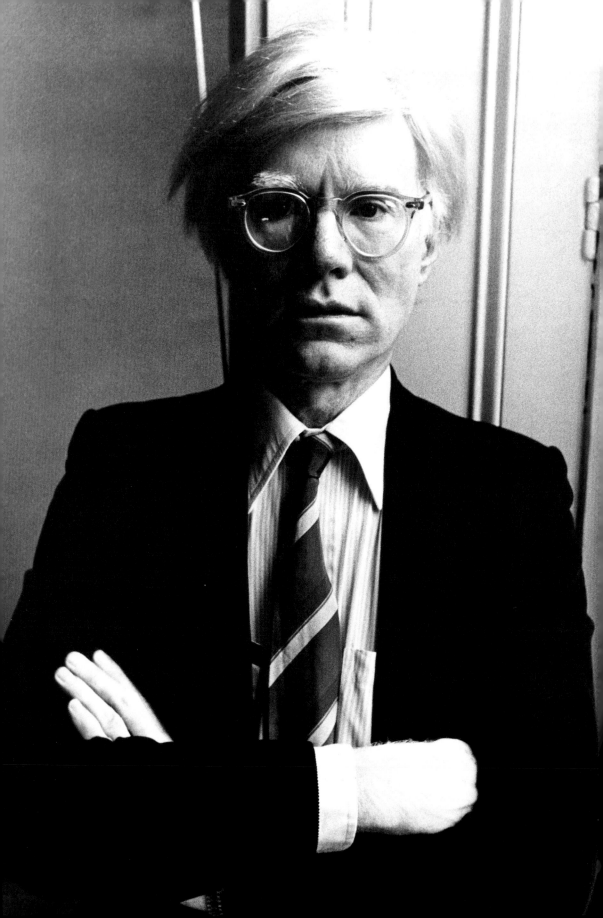

THE ART OF BUSINESS AND THE BUSINESS OF ART

'THE OFFICE'

In 1970, still in the grip of a painful recovery from the shooting, Warhol reached the pinnacle of his recognition in the international art world. A retrospective of his Pop paintings travelled across the United States and Europe, closing at the Whitney Museum of American Art, New York, in 1971. *The New York Times* art critic John Canaday gloated over the exhibition, 'The Warhol show is spectacularly installed ... The plain, inescapable fact, which will give pain to his enemies, is that Andy looks better than he has ever looked before.' Yet, at this climax, Warhol was evolving again. Nearly losing his life chastened him. He changed the subculture of 'The Factory' to the corporate culture of 'The Office', embarking on a series of business ventures with Fred Hughes and Vincent Fremont, who managed Andy Warhol Enterprises, Inc. He launched *Interview* magazine in 1969 to capitalize on the public's appetite for glamour, fashion and film. He continued producing films, but relinquished the directorial role to Paul Morrissey. And he dramatically expanded the print-making operation that he had begun as Factory Additions in the 1960s. But the principal activity at 'The Office' throughout the 1970s and 1980s was seeking and fulfilling portrait commissions.

The transition to 'The Office' was completed when the studio and business moved to 860 Broadway in 1974. At this time Warhol said, 'Being good in business is the most fascinating kind of art. Making money is art and working is art and good business is the best art.' During the 1970s he lived this axiom. The two sides of Warhol Enterprises – the business and the art – merged in his principal activity of painting portraits. Warhol openly viewed portraits as income, 'to bring home the bacon'. But he confessed that he also enjoyed portrait painting as it was a natural extension of his social life and his talent as a painter.

PORTRAIT PAINTER

Warhol's portraits began with images of celebrities in the 1960s. Then art collector Robert Scull commissioned a portrait of his wife Ethel in 1963. Instead of a traditional studio sitting for Mrs Scull, Warhol took her to the local '5 and Dime' store. She was surprised when Warhol put her in a photo booth and instructed her to make faces, telling her jokes to make her laugh. When she saw the resulting photos, she said, 'They are sensational.' Silkscreening the photos, the artist arranged thirty-six different images into a dynamic montage, presenting Mrs Scull in a variety of poses and with

[68]

[70]

◄ Warhol in the late 1970s.

different facial expressions. The novel approach of the photo booth gave the painting the freshness and vitality of a candid photograph. While finishing Mrs Scull's portrait, another patron commissioned him to do a self-portrait, launching a series that would continue for the rest of his career.

► FOCUS (4) SELF-PORTRAITS, P.93

Warhol's portraits became high fashion for high society. Nelson Rockefeller, scion of the oil family and Governor of the State of New York, commissioned a portrait of himself, then one of his wife Happy. The artist had begun the [69] portrait of Mrs Rockefeller as a two-metre (six-foot) canvas with a single screen when Valerie Solanas shot him. During his recovery Warhol reduced the screen to 17.8 × 15.2 cm (7 × 6 in), a size that he could manage more easily as he worked through his convalescence. The resulting portrait consists of a hundred screens of the same image in a monumental tribute to the Governor's wife.

Just before he was shot, Warhol's portrait business was beginning to blossom. The therapeutic value of working on Mrs Rockefeller's portrait encouraged Warhol to continue working in this vein, although he did not substantially expand his portrait painting business until the mid-1970s. One of his early portraits was of Dennis Hopper, who had just achieved stardom as actor- [71] director of the hit movie *Easy Rider* (1969). By choosing a celebrity for one of his first portraits of the 1970s, Warhol continued his childhood obsession, but the style is considerably different from the 1960s. The grainy, black-and-white 'head shot' of the actor is screened on top of a rectilinear patch of turquoise. The colour does not serve as a ground as in the portrait of Happy Rockefeller, and it is divorced from a direct relationship with the outline of the sitter's features, unlike his later, more developed portraits such as

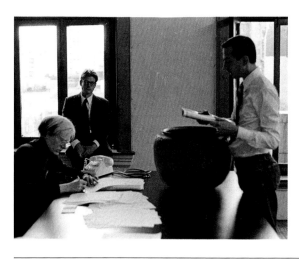

68
Warhol, Vincent Fremont and Fred Hughes at 'The Office', the Factory, New York 1970

Mick Jagger. In contrast to the solid grounds of his 1960s candid portraits, in the 1970s Warhol separated the form from the colour to create a dynamic design that would appeal to his clients, and that would also hint at the abstraction that would soon appear in his work.

By the middle of the decade, Warhol had refined his process. He would shoot Polaroids of the sitter, selecting some for the printer to make into acetates. These were then blown up to 101.6 × 101.6 cm (40 × 40 in) and screen-printed over a painted ground. For an artist who had 'retired' from painting a decade earlier, Warhol proudly reported that he was hand-painting the grounds of his portraits and putting 'style' back into his pictures. For the portrait of his friend Henry Geldzahler, the artist exaggerated the brushstrokes swirling around the head of the curator, who had so ardently supported Warhol's mechanically printed Pop paintings. With broad sweeps of his brush, he spread dense layers of yellow, red and blue, wet-into-wet, into a chromatic halo that silhouetted Geldzahler's distinguished features.

The roster of Warhol's portrait patrons records the rich and famous pop music, art world and film stars of the era, who mingled with Warhol during his nightly jaunts on the society circuit. Unlike on his rounds as a commercial artist in the 1950s, Warhol was no longer carrying his portfolio, but had a tape recorder in his hand, a camera around his neck and a beautiful woman or handsome man on his arm. The voyeur of bohemian decadence at the 1960s Factory had transformed himself into the mirror of New York City's high society in the 1970s. At the clubs, Warhol worked the crowd. He marketed his persona so that it appeared in the society columns and tabloids. He rubbed shoulders with the newest stars of the day, gathering gossip and soliciting articles for *Interview* magazine, and securing portrait commissions. But he began to alienate the art establishment, who perceived Warhol's socializing as overt commercialism. Critics and curators, who had held him in high esteem in 1970, were now complaining that he was not creating works of art, but operating a business.

PAINTING AND POLITICS

Despite this criticism, Warhol did create work that reflected important social and political issues of the 1970s, as he had in the 1960s, when he claimed to present 'symbols of the harsh, impersonal products and brash materialistic objects on which America is built today'. Unlike his portraits of this period, these were not produced on commission; he was making art for himself. Responding to President Richard Nixon's visit to China in 1972, Warhol recognized the significance of Mao Zedong opening his communist country to the capitalist west and created a series of paintings of Chairman Mao, many on a monumental scale. Using the frontispiece from Mao's *Little Red Book* (1962), the artist developed a series that rivalled the Marilyn images in number and dramatically exceeded them in scale. Using a mop, he swabbed

thickly layered paint onto which he screened the image of the venerable Chairman. The poignancy of this series lies in Warhol's awareness of the iconic nature of the official photo portrait of Mao and in the significance of this moment in history.

Warhol continued to create savvy political statements when he was invited by the Democratic Party to contribute a print to support George McGovern's presidential campaign. With his uncanny prescience, he printed an image of Richard Nixon, the incumbent Republican candidate for president over the caption 'Vote McGovern'. Shortly after Nixon was re-elected, the Watergate scandal erupted, leading to his ignominious resignation in 1974. The breach of public trust that Nixon's authorization of espionage represented left the country doubting the integrity of its elected officials, manifest in Nixon's menacing grimace in this print. [75]

While in Rome a few years later, the Italian press asked Warhol if his images of black and Hispanic transvestites (*Ladies and Gentlemen*) were a critique of capitalism. Europe was enmeshed in a decade-long wave of communist terrorist activity, involving the kidnapping and killing of politicians, judges and bankers. The tension between communist and capitalist governments was a key current issue. Feeling the political pulse, Warhol composed his *Hammer and Sickle* series. Unable to find a suitable mass media image, Warhol went to the hardware shop and bought a selection of hammers and sickles, and then photographed a variety of still life arrangements. He assembled a few hardware/Communist Party emblems casting long shadows, which he then screened onto painterly grounds. Publicly, Warhol disavowed any overt political statements in these works, yet they clearly refer to the political issues of the Cold War. [76] [77]

MEMENTO MORI

At the same time, Warhol executed a series of *Skulls* that merge still life and portraiture into a memento mori (reminder of death), reflections on our demise. As in the *Hammer and Sickle* series, he arranged a still life with stage lighting and shot some Polaroids. The *Skulls* are among the most poignant images of mortality in the twentieth century, indicating that the artist, approaching mid-life, was beginning to grapple with his own mortality. He had both feared and been obsessed with death since the demise of his father when he was a child. His Pop celebrity portraits were tinged with tragedy. His *Death and Disaster* series in the 1960s graphically confronted the topic. He survived an attempt on his own life at the same time as a rash of shootings in the United States claimed the lives of John F. Kennedy in 1963, and Martin Luther King and Robert Kennedy in 1968. Rebellious groups were terrorizing Europe. Also, with the escalation of the Cold War, the threat of nuclear holocaust loomed. The artist confronted death at each stage of his life and meditated on the subject throughout his career. [78]

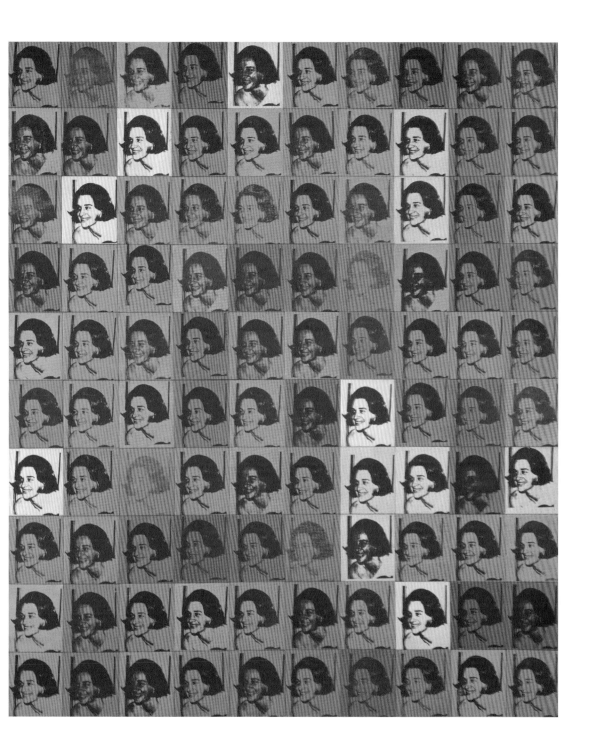

69
Happy Rockefeller (Mrs Nelson Rockefeller), 1968
Acrylic and silkscreen ink on linen
181.6 × 149.9 cm (71 ½ × 59 in)
Private collection

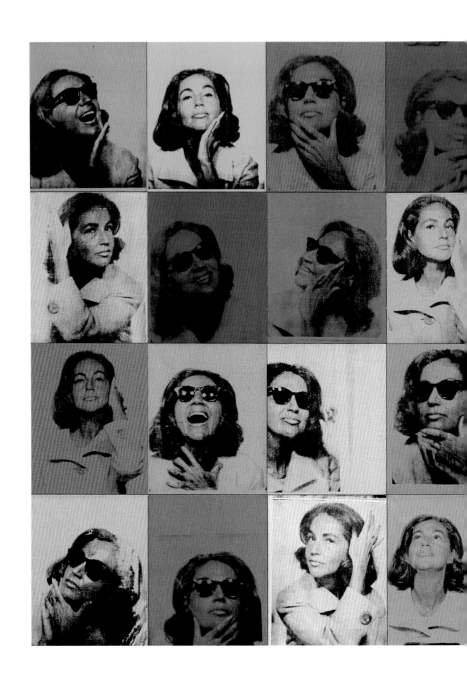

70
Ethel Scull 36 Times, 1963
Silkscreen ink, acrylic and silver paint on linen
50.8 × 40.6 cm (20 × 16 in) each
Whitney Museum of American Art, New York

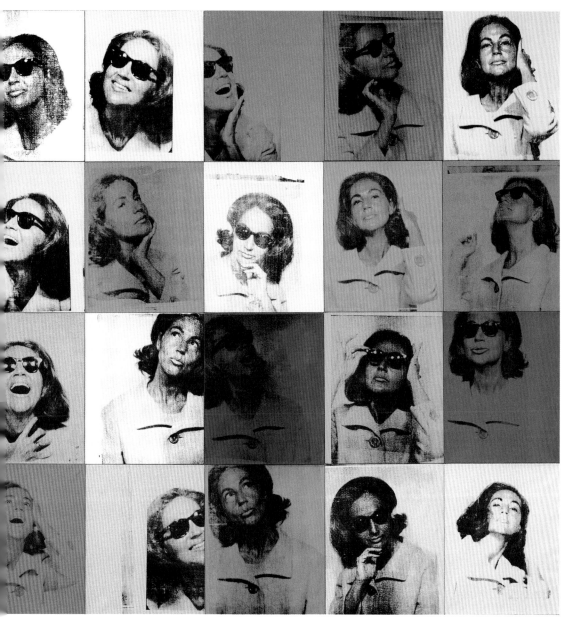

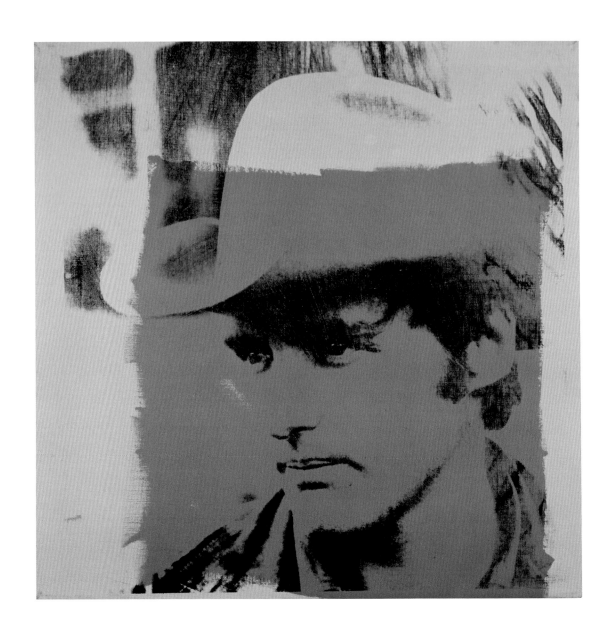

71
Dennis Hopper, 1971
Synthetic polymer paint and silkscreen
ink on canvas
101.6 × 101.6 cm (40 × 40 in)
Private collection

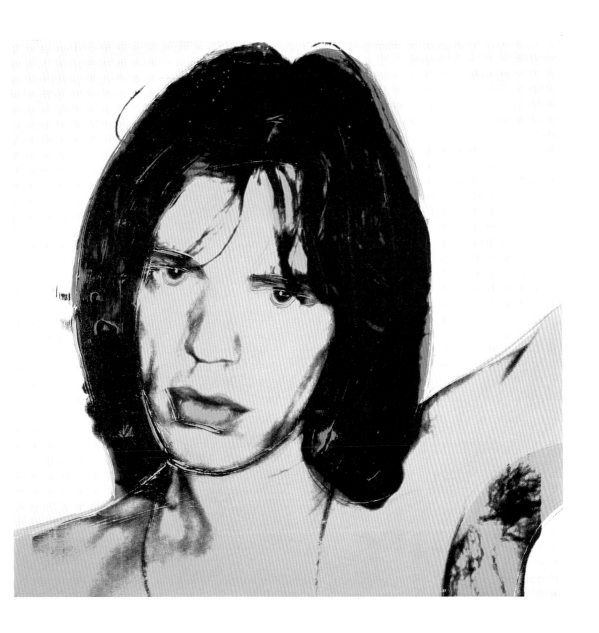

72
Mick Jagger, 1975–6
Synthetic polymer paint and silkscreen
ink on canvas
101.6 × 101.6 cm (40 × 40 in)
Private collection

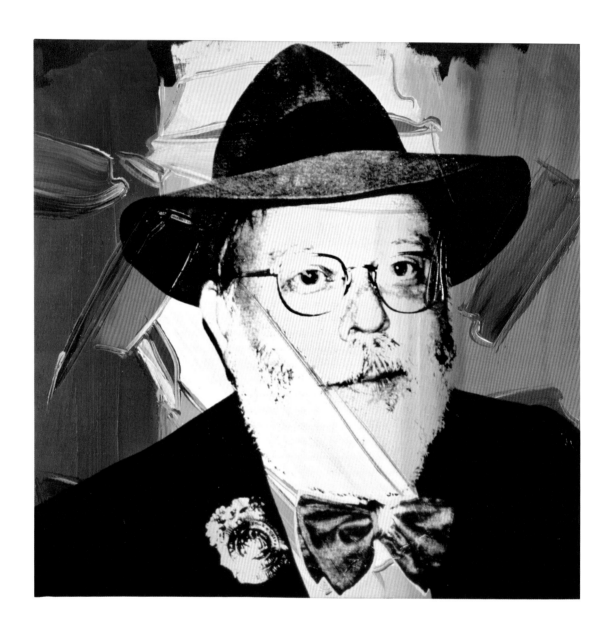

73
Henry Geldzahler, 1979
Synthetic polymer paint and silkscreen
ink on canvas
101.6 × 101.6 cm (40 × 40 in)
Private collection

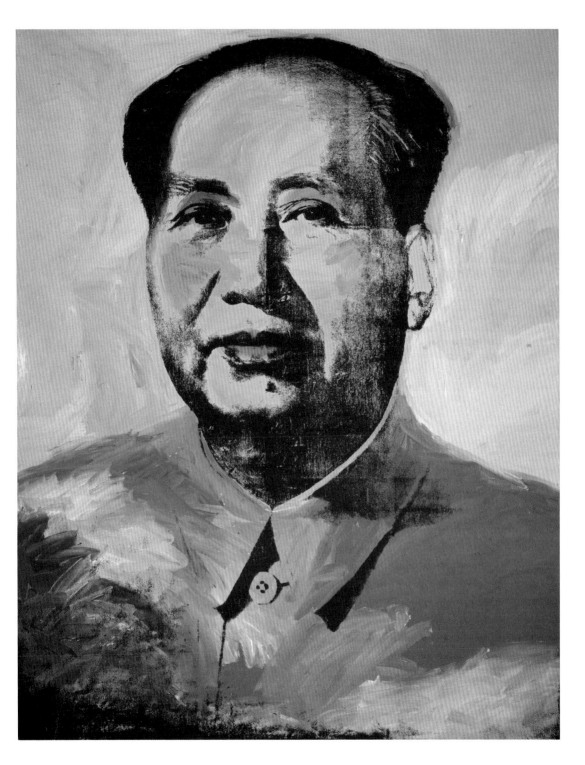

74
Mao, 1972
Synthetic polymer paint and silkscreen
ink on canvas
448.3 × 346.7 cm (176 ½ × 136 ½ in)
The Art Institute of Chicago

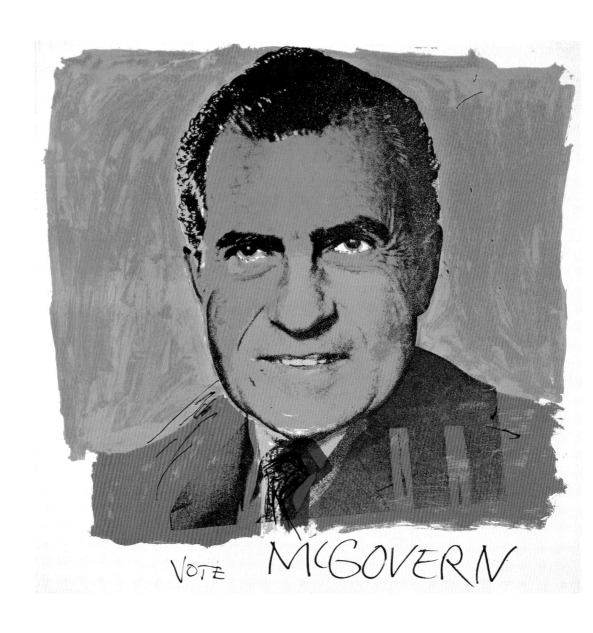

75
Vote McGovern, 1972
Screenprint on Arches 88 paper
106.7 × 106.7 cm (42 × 42 in)
Gemini G.E.L. Art Gallery, Los Angeles

76
Ladies and Gentlemen, 1975
Synthetic polymer paint and
silkscreen ink on canvas
127 × 101.6 cm (50 × 40 in)
The Mugrabi Collection, New York

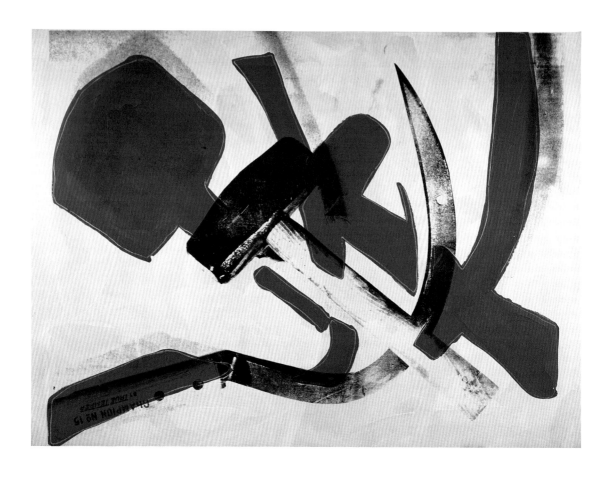

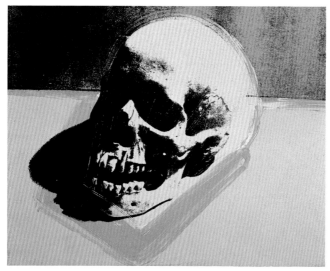

77
Hammer and Sickle, 1976
Synthetic polymer paint and
silkscreen ink on linen
304.8 × 406.4 cm (120 × 160 in)
The Museum of Modern Art, New York

78
Skull, 1976
Synthetic polymer paint and
silkscreen ink on linen
38.1 × 48.3 cm (15 × 19 in)
The Andy Warhol Museum, Pittsburgh

FOCUS (4)

SELF-PORTRAITS

Many artists have left posterity with images of themselves, notably, among others, Rembrandt and Picasso. When we look at their self-portraits we glean insights into the character of the artist. But it is important to remember that the artists have consciously crafted the impression that they wish to leave us. Warhol has joined the prominent self-portraitists over history. Tracing the development of his portrayals provides insight into his evolving construction of a public persona.

Warhol may be the most reproduced face in the history of art, having appeared in magazines, tabloids and on television for decades. In his earliest self-portraits from 1942 we see the youthful Andrew Warhola aspiring to master the rendering of his likeness [9]. At this formative stage, the fledgling artist already demonstrates an ability in drawing, conveying his youthful energy and personality with an assurance of line around his eyes and lips that is seldom found in the work of a teenager. In the rare self-portraits that he drew in the 1950s, during his years as a commercial artist, we see a shy man who hides his features from the viewer [16]. Yet, when he achieves celebrity as a Pop star (1963–4), Warhol portrays himself with the confidence gained from his artistic success. Employing the photo booth as his portrait studio, the artist poses for the camera behind dark sunglasses with his tie loosened around his neck and wearing a trench coat in the guise of a gangster [79]. For his second self-portrait, he removed his sunglasses, self-confidently thrusted his jaw forwards and gazed directly into the eyes of the viewer [80]. By 1967 he is established as the so-called 'Mum Voyeur' whose art is a mirror of society, with his self-portrait, head in hand, one eye observing our actions, while the other is mysteriously hidden in shadow [81].

Immediately after Valerie Solanas's attempt to kill Warhol, he took Polaroids of his wounds and the fashion photographer Richard Avedon portrayed him in images that evoke the impression of the artist as a martyr (1969). Warhol painted no further self-portraits until he reached the age of fifty, in 1978 [83]. In these works, Warhol reveals a reflective soul, who is examining his career and evaluating the course of his life.

Nearly a decade after these self-portraits, Warhol produced another series in 1986, the 'Fright Wig' self-portraits [82]. In these paintings the artist created what was to become the most iconic image of himself. Commissioned by London art dealer Anthony d'Offay, these were created during a difficult time in his life when he was confronting the loss of friends and the erosion of his own fragile health. At the opening of the show the self-conscious Warhol described the paintings as 'the worst pictures you've ever seen of yourself'. Yet, these self-portraits intrigued him enough to continue the series beyond the commission and create seven different variations on the subject: with the wig spiked up, closely cropped around his face, in negative, with glasses, and on camouflage grounds. D'Offay likened the images to a death mask and, indeed, in these paintings we see Warhol as the wizened artist, far removed from the wide-eyed days of Pop stardom, and looking into the face of his own mortality. Far from ceding to the finality of his deathly visage, however, the prospect of his demise appears to have motivated the artist into a torrent of creative activity over the last year of his life.

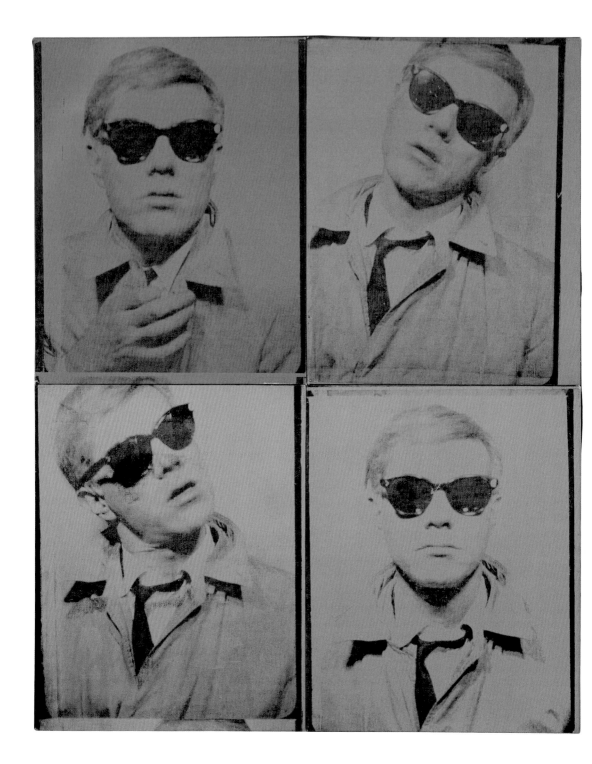

79
Self-Portrait, 1963–4
Acrylic and silkscreen ink on linen
50.8 × 40.6 cm (20 × 16 in) each
Private collection

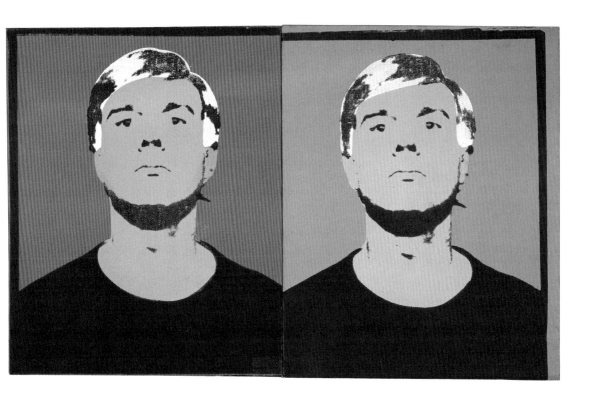

80
Self-Portrait, 1964
Acrylic, silver paint and silkscreen ink on linen
50.8 × 40.6 cm (20 × 16 in) each
Private collection

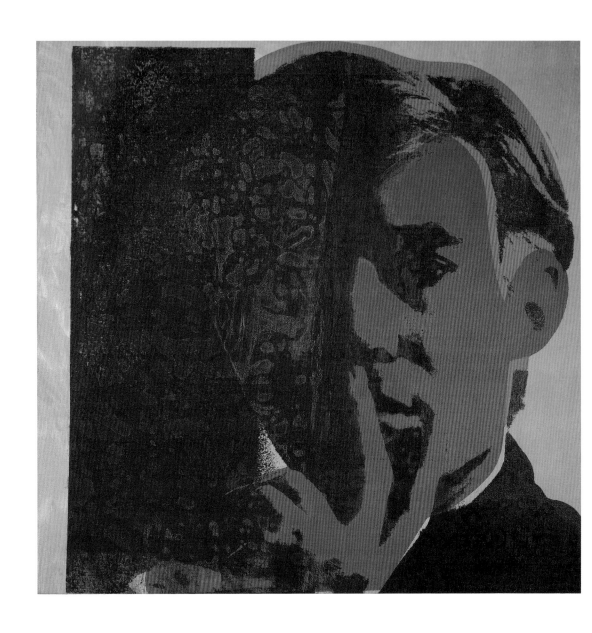

81
Self-Portrait, 1967
Acrylic, silkscreen ink and pencil on linen
182.9 × 182.9 cm (72 × 72 in)
Private collection

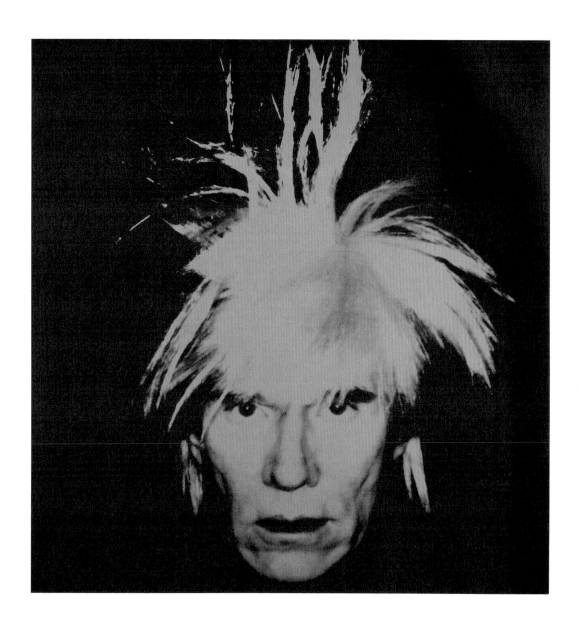

82
Self-Portrait, 1986
Synthetic polymer paint and silkscreen
ink on canvas
203.2 × 193 cm (80 × 76 in)
Private collection

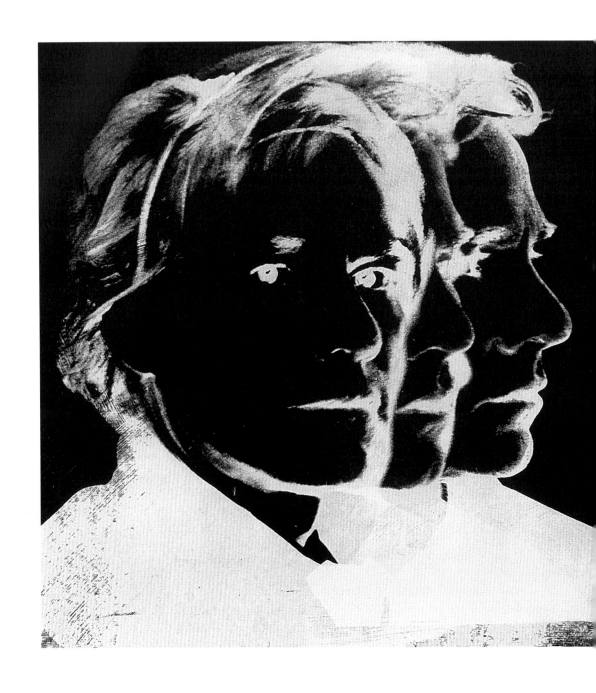

83
Self-Portrait, 1978
Synthetic polymer paint and silkscreen ink
on canvas
101.6 × 101.6 (40 × 40 in) each
The Andy Warhol Museum, Pittsburgh

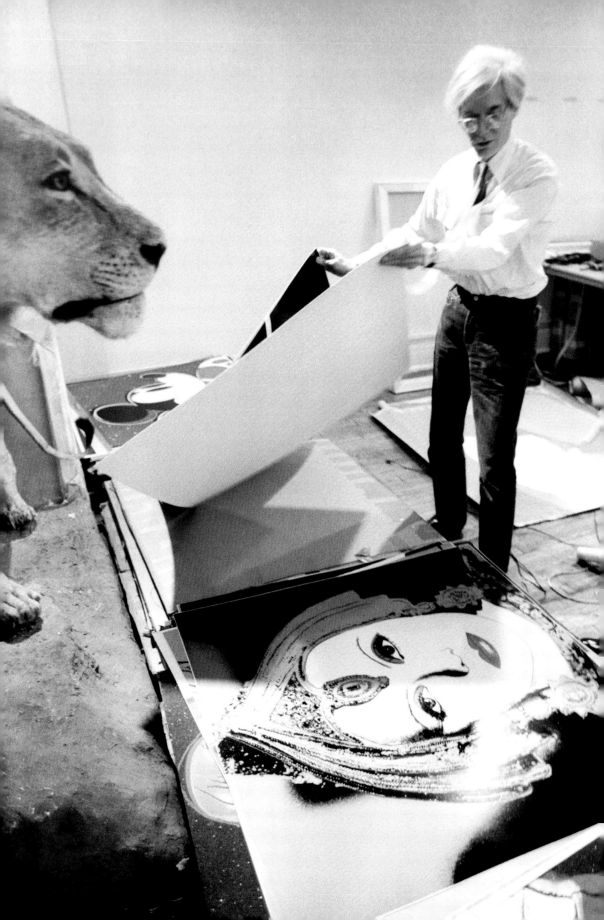

THE HAND AND THE MACHINE

[87]

MID-LIFE CRISIS

Despite his reflections on mortality, Warhol continued his non-stop social-izing with the world's rich and famous publishing their gossip in *Interview* and painting their portraits – such as that of Liza Minnelli among others – through the 1970s and 1980s. His business ventures continued unabated. Although he stopped making films, he entered into broadcast television and he became a male model, promoting fashions and consumer products. At the same time he accelerated his print production, producing almost half of his total printed work in the last decade of his life. He essentially branded the Andy Warhol personality and aura, and marketed it to the public, using the vehicles of mass distribution.

▶ FOCUS ⑤ PRINTS, P.124

[78]

Lurking behind this flamboyant public image, Warhol was gripped by a prototypical mid-life crisis first manifest in his *Skull* paintings of 1976. He had turned fifty in August 1978, precisely a decade since the assassination attempt. The scathing criticisms of his commercial portraits caused him anguish. Warhol grew concerned about his artistic legacy and confronted his critical self-examination with a burst of concerted energy. While continu-ing the variety of his business ventures, he returned to the studio and over the next decade experimented with new techniques, reinvented old subjects and produced a prodigious amount of art in an explosion of creativity and innovation comparable only to the apogee of the 1960s. In 1963, at the dawn of the Pop revolution, Warhol said, 'You ought to be able to be an Abstract Expressionist next week, or a Pop artist, or a realist, without feeling you've given up something ... I think that would be so great, to be able to change styles.' He finally realized this ambition during the last decade of his career in a series of personal paintings that were rarely seen during his lifetime, but reflect his aspiration to be considered among history's great painters.

[83]

The doubt plaguing the artist surfaces in the series of self-portraits that he painted in 1978, the first self-portraits since the 'Mum Voyeur' paintings over a decade earlier. Gone is the youthful, self-confident persona of the 1960s. The dizzying multiple exposures convey a confused identity. His sharp red and white eyes pierce through the negative images, suggesting the depth of his self-examination. As in the past, a revelatory artistic encounter motivated Warhol to work in a new direction. During the summer of 1977, he

◀ Warhol looking at prints of Greta Garbo at the Factory, 1981.

travelled to Paris to attend the opening of the Centre Pompidou. Pontus Hulten, founding director of the Centre Pompidou, escorted Warhol and his entourage around the art museums of Paris. The experience invigorated Warhol, who wrote in his diary, 'I had energy and wanted to rush home and paint and stop doing society portraits.'

TOWARDS ABSTRACTION

That summer Warhol began a radically new series, the *Oxidation Paintings*. For the first time in his career, the infamous creator of photo-transfer silk-screen portraits of people and products produced abstract paintings. The artist tested the chemical reaction of the acid contained in urine with a variety of metallic paints to generate sensuous showers of brown and green that rain across the golden ground of the surface. The all-over composition of the *Oxidation Paintings* recalls Abstract Expressionist paintings, yet also parodies them. Warhol simultaneously admired, envied and rebelled against the Abstract Expressionists. The resulting visceral presence of his paintings emulates the work of his predecessors, but the sordid details of their making confirms his rebellious position in contrast to their existential spirituality. In the *Oxidation Paintings* he created abstractions without their sacred gestural brushstrokes, using instead the natural flow of urine for a painterly effect.

[104]

► FOCUS ⑥ OXIDATION PAINTINGS, P.129

Warhol's enthusiasm for the *Oxidations* spurred him to continue making abstractions. Reverting to his still life methods, the artist arranged matte boards and illuminated them to cast long shadows. With his mop, he swept thick swathes of paint onto which he screened Polaroids of dark shadows. The German art dealer Heiner Friedrich commissioned the *Shadows* series of paintings to exhibit in his new SoHo location. For the exhibition, the canvases ringed the walls of the gallery, enveloping visitors with their mysterious forms and painterly surfaces. What were these evocative, ephemeral shapes? After all, Warhol had always painted recognizable objects. The *Oxidation Paintings* and the *Shadows* were the breakthrough images of his last decade, when he expanded his studio practice to explore his entire repertoire of painting techniques.

[105, 106]

► FOCUS ⑦ SHADOWS, P.132

[88]

The abstract *Yarn* series resulted from a Florentine yarn manufacturer commissioning a 'product portrait'. The client selected a simple image of a spool with a dangling thread. Another shot from the session motivated the artist to print for himself bolts of canvas with wool strewn into a colourful cacophony across the surface of the canvas. These spectacular paintings

[84]

recall Jackson Pollock's drip paintings, etched in Warhol's mind from the time of his arrival in New York City when *Life* magazine had asked, 'Is he [Pollock] the greatest living American painter?' Yet, in his ironic manner, Warhol recreates the drip technique entirely by screenprinting.

[90]

Continuing to pursue abstraction, Warhol next developed his *Rorschach* series, reverting to the art school exercise of folding sheets of paper to create mirror images. Taking over the whole of his studio to accommodate the paintings, which reached 3 to 4 metres (10 to 14 feet) in length, the artist painted half of the canvas, folded it, and then the entire studio staff, on their hands and knees, rolled large dowels to press the pigment onto the other half. Here Warhol translated his blotted-line drawings into monumental paintings. Like their namesake – the ink blots conceived by Hermann Rorschach as psychiatric tests – the sinewy lines and mottled pools of the *Rorschach* paintings evoke a host of associations.

At the same time as he was exploring abstraction, Warhol reached into his past to reinvent some of his successful subjects from his years as a commer-

[89, 91, 92]

cial artist and a Pop artist. As the source for his *Black and White Ads* series, he returned to his first hand-painted Pop pictures from 1961, cutting out ads, projecting them and then tracing the projections. However, in the 1980s *Ads*

[93]

pictures he loosely brushed the drawings, then screened them onto canvas. The finished paintings appear to be hand-painted, blurring the distinction between the handmade and the mechanically reproduced.

84
Jackson Pollock (1912–1956)
working on *Painting Number 32, 1950*
in his studio, Springs, New York, 1950

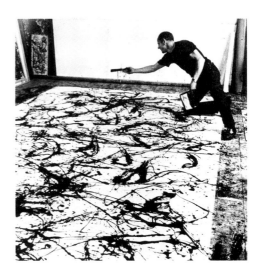

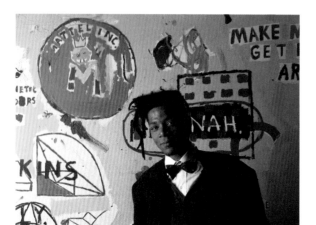

COLLABORATIONS WITH BASQUIAT

In 1979, months after Warhol debuted his *Shadows* series, the Neo-Expressionists surged onto the New York art scene, bringing a revival of bold, colourful painting. With his uncanny prescience, Warhol was perched at the forefront of the resurgent interest in painting. When the interest in the Neo-Expressionists was at its height, the Swiss art dealer Bruno Bischofberger brought the young painter Jean-Michel Basquiat to Warhol's studio for lunch [85, 96] in 1982. Warhol was impressed by the young artist, who had begun as a graffiti artist and was now with the prestigious European dealer. He invited Basquiat back to paint in the studio, launching a sequence of collaborations that lasted over two years.

Typically, Warhol started these collaborations by screening logos onto [95, 97] canvas. Then Basquiat would paint over the ground with his characteristic black faces and graffiti scrawls. As the collaboration progressed, the artists influenced each other. For Warhol, the most successful of these paintings were those on which the two artists' touch is indistinguishable, as in *African* [98] *Masks*, which he described as a 'masterpiece'. Across the surface of this massive mural parade black-and-white masks, painted by one artist then the other, responding to each other's marks in a syncopated duet. Through this process, the two became close friends, painting together during the day and clubbing at night. However, a review in *The New York Times* in 1985 brought their relationship to a crashing halt when the critic accused Basquiat of being Warhol's 'mascot'. Warhol fondly reminisced in his diary that, 'Jean-Michel got me into painting differently, and that's a good thing.' Charged by Basquiat's energy, Warhol returned to figure painting by hand, in contravention of his Pop Art aesthetics.

THE LAST YEARS

The loss of his close friend and collaborator disheartened Warhol. At the same time his partner was dying of AIDS and his own health was faltering. Despite these serious personal issues, he worked harder than ever. Andy Warhol Enterprises, Inc. managed his television series, secured a steady supply of modelling jobs and contracted a continuous stream of editioned prints and commissioned portraits. At the same time, the artist was painting in his studio. He worked daily – evenings and weekends – to keep up with the astounding output in both business and art. Between 1985 and 1986, Warhol produced more works, in more series, in larger numbers and on a larger scale, than many artists do in their entire careers. At this point he commanded a vast repertoire of techniques and could conceive and execute a wide variety of abstract and figurative paintings and prints. Three series from 1986 are exemplary: the 'Fright Wig' self-portraits, the *Camouflage* paintings and *The Last Supper* paintings.

'FRIGHT WIGS'

[82]

Arguably, Warhol's signature self-portrait is the so-called 'Fright Wig'. For this series, Warhol's personal assistant shot a series of Polaroids with his wig coifed in emulation of Basquiat's Rasta hairstyle. With a blank stare and gaping mouth, Warhol's disembodied head appears electrified with brilliant strands of hair burnt into the deep black background. The haunting image departs from the youthful bravura of the 1960s and his mid-life crisis of 1978. These self-portraits present a wizened man confronting the realities of advancing age. This suite of self-portraits resemble a death mask or the veil of St Veronica, said to bear an image of Christ's face.

CAMOUFLAGE

[99]

Camouflage was Warhol's favourite design of this period, appearing in some of the self-portraits, the *Statue of Liberty*, *The Last Supper* series and in an extended series of its own. Scavenging for more painting ideas, he sent his assistant to the army surplus store to buy a swatch of military camouflage. By outlining the pattern and printing it, the artist found a ready-made design for a repetitive abstract pattern with the potential for infinite variation. He extended the pattern to mural-sized lengths and printed a variety of different colours from traditional military colours to brilliant primaries and delicate pastels. The *Camouflage* approach served as abstract wallpaper for this late period just as the *Cow* had served as Pop wallpaper in the 1960s.

[45]

THE LAST SUPPER

[108]

While printing his self-portraits and *Camouflage* abstractions, Warhol simultaneously worked on a commission in homage to a masterpiece of western art, Leonardo da Vinci's *The Last Supper*. The Greek art dealer

Alexandre Iolas, who had hosted Warhol's first professional art exhibition in 1952 ('Fifteen Drawings Based on the Writings of Truman Capote'), purchased a gallery in Milan across the street from Leonardo's mural and wanted to open with a show in homage to the fresco. The subject obsessed Warhol and his *Last Supper* series became the most ambitious of his career. He worked diligently over a year on variations of Leonardo's mural, silkscreening and hand-painting canvases, large and small, isolating details, rearranging the composition and painting symbolic commercial logos. The exhibition opened during the Christmas holidays in December 1986 and represented the first public expression of his faith. Warhol was a practising Catholic, who was raised in the Church by his mother and attended mass in private during his decades as an artist. The emblems of wisdom, light and peace that adorn these paintings confirm the religious beliefs of a man who kept a cross and an icon at his bedside. Yet, ever the paradox, he also embraced the Pop irony of price tags and commercial logos, forcing us to consider his sincerity sceptically. In his last interview he emphasized that the series was a commission and disavowed any personal religious sentiments, claiming, 'I'm still a commercial artist. I was always a commercial artist.'

▶ FOCUS ⑧ THE LAST SUPPER, P.136

Shortly after this interview, Warhol modelled fashions with jazz musician Miles Davis at the hip East Village club, The Tunnel. With his photographer and videographer recording the proceedings, Warhol appeared more pale and gaunt than usual. As he walked onto the stage he visibly winced in pain. He struggled and had to end the session early. The next day he checked into hospital for emergency gall bladder surgery. The operation was successful, but an infection set in and Warhol died before it could be treated. The sudden demise of Warhol shocked the legions of people that he had touched in the worlds of fashion, film, music and art. They were surprised to learn from John Richardson's eulogy about the 'spiritual side that he hid from all but his closest friends,' noting that 'it's the key to the artist's psyche.' When his colleagues opened the door to his studio after his death, they discovered his personal side in the monumental, hand-painted *The Last Supper* paintings that dominated the room. These canvases, with their delicately laid lines, painted on a scale greater than that ever attempted by the artist, testify to his technical ability, his spiritual beliefs and his aspirations to greatness.

In the prodigious production of his final decade, Warhol drew upon the many years of his experience to consummate his artistic contributions. Dying suddenly at the age of fifty-eight, the artist lived a short life, but had a long career. Still middle-aged, Warhol was in the midst of reinventing his painting practice and had just launched a new body of work, his stitched photographs. It is consistent with his role as a public personality that his last appearance

[86]

[107]

[94]

86
Warhol appears with
Miles Davis at a fashion
show in the Tunnel Club,
New York, 17 February 1987

was as a fashion model with the jazz innovator Miles Davis. He had cultivated
a persona that played upon the public's appetite for celebrity, glamour,
sensation, wealth and beauty. It is not surprising that in his last interview he
refers to his roots as a commercial artist. From his beginning in illustration
in the 1950s, through his Pop Art of the 1960s and his portrait business of the
1970s, he linked business with art. He transformed art and culture with his
innovative use of photo-transfer silkscreen printing, introducing mechanical
reproduction into our visual culture. But in paradoxical fashion he also valued
the role of art in addressing profound questions of life, questions that he
asked in his late self-portraits and *The Last Supper* paintings. In his later years
he probed the meaning behind the dialectic of his art and business, asking,
'What is art? Does it really come out of you or is it a product?'

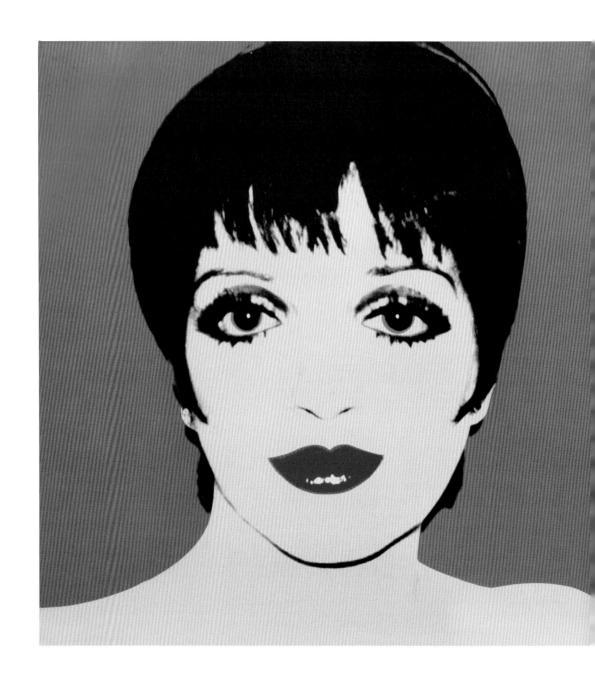

87
Liza Minnelli, 1979
Synthetic polymer paint and silkscreen
ink on canvas
101.6 × 101.6 cm (40 × 40 in) each
The Andy Warhol Museum, Pittsburgh

88
Yarn, 1983
Acrylic and silkscreen ink on canvas
137.1 × 523.2 cm (54 × 206 in)
Kunsthalle Bielefeld

Filpucci, a Florentine yarn manufacturer, commissioned Warhol to create a series of paintings of its products in 1983. Warhol so enjoyed these that he created a series of approximately a dozen including this monumental 5-metre (17-foot) wide canvas. Interestingly Filpucci purchased a tame image of a spool of yarn, not the spaghetti-strewn, all-over compositions that Warhol preferred.

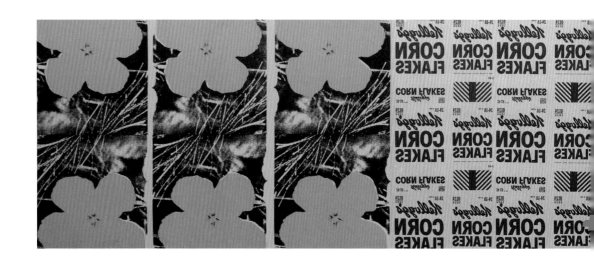

89
Big Retrospective Painting, 1979
Acrylic and silkscreen ink on canvas
2 × 10.8 m (6 ½ × 35 ½ ft)
Private collection

Warhol asked his close friend Larry Rivers to recommend some new subjects for his paintings and he suggested that he remake some of his 'golden oldies'. Mining his most successful Pop Art images, Warhol worked on new compositions between 1978 and 1979 and made alternately positive and negative images of his most famous works.

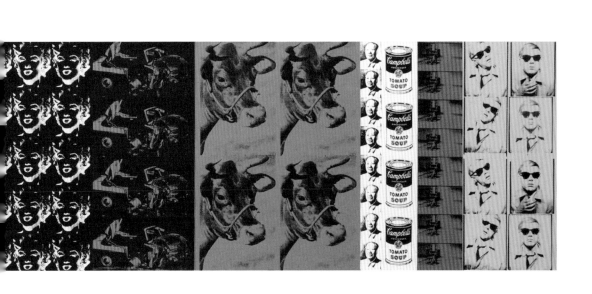

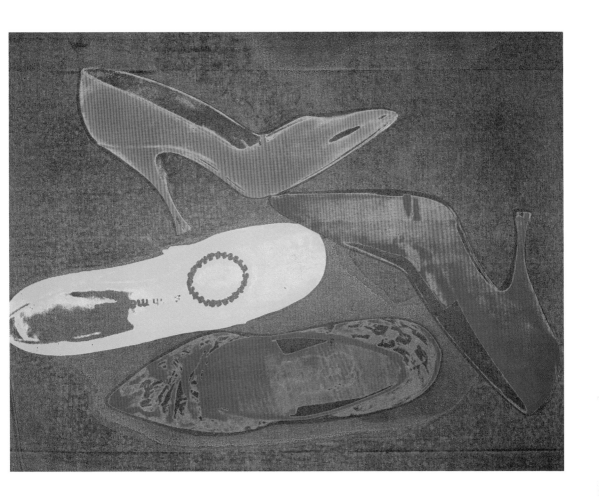

Warhol asked his studio assistant, Jay Shriver, for 'a new idea'. Shriver suggested inkblot Rorschach tests, which Warhol had done as exercises when he was a student at the Carnegie Institute. Enthusiastic about the idea Warhol enlarged these folded-paper studies into monumental, monochrome paintings. Like their namesake, the tests conceived by the Swiss psychiatrist Hermann Rorschach, Warhol's *Rorschach* paintings evoke deep mysteries lurking under the surface. Yet they also function as abstract designs with delicate lacework and richly mottled pools of ink.

◄ 90
Rorschach, 1984
Acrylic on canvas
401.3 × 279.4 cm
(158 × 110 in)
The Baltimore
Museum of Art

91
Diamond Dust Shoes, 1980–1
Synthetic polymer paint, diamond dust
and silkscreen ink on canvas
228.6 × 177.8 cm (90 × 70 in)
The Andy Warhol Foundation for
the Visual Arts, Inc.

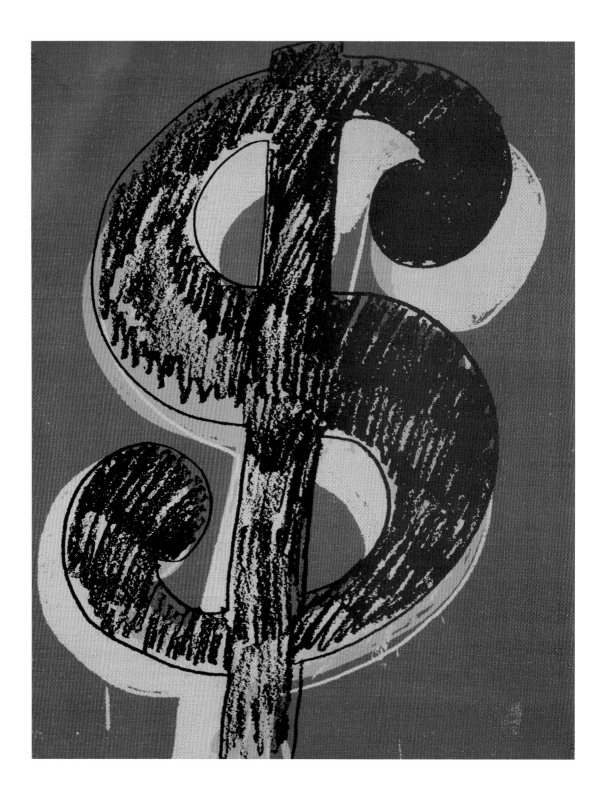

◄ 92
Dollar Sign, 1981
Synthetic polymer paint and silkscreen
ink on canvas
228.6 × 177.8 cm (90 × 70 in)
The Andy Warhol Foundation for
the Visual Arts, Inc.

93
Double $5/Weightlifter, 1985–6
Acrylic on linen
294.6 × 549.9 cm (116 × 216 ½ in)
The Andy Warhol Museum, Pittsburgh

As he was experimenting with new painting
techniques, Warhol returned to his earliest
hand-painted Pop pictures with the idea
of creating a new series of *Black and White
Ads*. In these works Warhol drew new ads
from mass-culture magazines and newspapers,
projected them, and painted them, some, like
Weightlifter, are on a large-scale displaying
his remarkable painting skills.

94
Untitled Stitched Photograph, 1976–86
Four gelatin silver prints stitched with thread
54.6 × 69.9 cm (21½ × 27 ½ in)

Since 1976 Warhol began to take 35mm photographs recording his daily life, the people he met and the places he visited during his active social schedule. Concurrently with his 'Last Supper' exhibition at Alexandre Iolas Gallery, Milan, he presented an exhibition in January 1987 at the Robert Miller Gallery, New York, that revealed this previously unknown side of the artist's creativity. In these works a seamstress sewed individual 20.3 × 25.4 cm (8 × 10 inch) black-and-white photographs to produce serial photographic imagery.

95
GE Emblem, 1985–6
Synthetic polymer paint on canvas
137.1 × 111.7 cm (54 × 44 in)
The Andy Warhol Foundation for
the Visual Arts, Inc.

96
*Jean-Michel Basquiat, c.*1984
Synthetic polymer paint, silkscreen ink
and urine on canvas
101.6 × 101.6 cm (40 × 40 in) each
The Andy Warhol Museum, Pittsburgh

97
Andy Warhol and
Jean-Michel Basquiat (1960–1988)
Arm and Hammer (II), 1985
Acrylic on canvas
193 × 285 cm (76 × 112 in)
Galerie Bruno Bischofberger, Zurich

98
Andy Warhol and Jean-Michel Basquiat
African Masks, 1984
Acrylic and silkscreen ink on canvas
2 × 10.6 m (6 ½ × 34 ¾ ft)
Private collection

In 1982 Warhol began his collaboration with Jean-Michel Basquiat. The impetuousness of the youthful Basquiat energized Warhol's studio and his social life. The two artists immediately bonded and developed a close relationship over the next two-and-a-half years. The most ambitious of the collaborations is *African Masks*, a remarkable frieze of figures, alternating between black-and-white faces and totemic forms. In his diary entry for 29 May 1984, Warhol stated, 'We painted an African masterpiece together. One hundred feet long. He's better than I am, though.'

99
Camouflage, 1986
Acrylic and silkscreen ink on canvas
2 × 10.2 m (6 ½ × 33 ½ ft)
Private collection

FOCUS ⑤

PRINTS

Warhol's artistic practice is predicated on reproductive techniques and serial images, including an extensive exploration of printmaking. He learned a range of printing techniques while studying design and illustration at Carnegie Tech. He started his art career on the blotted-line technique, and he created his Pop Art paintings with a variety of projections, stencils and rubber stamps, until he discovered the photo-transfer silkscreen. He ardently wished for his images to be distributed as widely as possible, so his earliest prints were inexpensive, often printed as commercial offset lithography and even Xeroxes on paper bags, T-shirts and record covers. As he became more experienced at printmaking, he developed it as a means of exploring artistic ideas, in the same way that many artists would use drawing.

Warhol made his first editioned print in 1962, a black-and-white photo-engraving of a cooking pot on commission as part of a portfolio with twenty artists. He did not fully develop his printmaking until 1964, after he had been working with the photo-transfer silkscreen process on his paintings for over a year. The Wadsworth Atheneum art museum invited him to contribute a print to their portfolio of *Ten Works by Ten Painters*. At the time he was working on his *Death and Disaster* series and he submitted a stark black-and-white screenprint of the *Birmingham Race Riot* [100], appropriated from a newspaper. The portfolio included work by Robert Indiana (b. 1928), Roy Lichtenstein (1923–1997) and Frank Stella (b. 1936), and was extremely popular, helping to launch the dramatic expansion of printmaking across the United States and Europe through the 1970s and 1980s. Warhol stood at the forefront of the printmaking revolution, as he had in commercial art and Pop Art.

After his initial forays into the field, Warhol began to reproduce his popular images in large editions, using the same silkscreen process on paper that he used on canvas. Over the 1960s, he made portfolios of many of his signature images of *Flowers* [48], *Liz* [49], *Jackie*, *Marilyn* [57] and *Campbell's Soup* [53]. The demand for his prints and their financial success led Warhol to launch Factory Additions in 1965. The business proved to be extremely lucrative and helped finance his filmmaking. But as early as 1966, the artist began to discover new artistic possibilities for printmaking when he editioned the *Cow Wallpaper* [45] that he presented at Leo Castelli Gallery in 1966. With this work, Warhol employed the decorative device of wallpaper to construct an encompassing environmental experience. This initiated two decades of experimental printmaking for the artist.

In the 1970s, printmaking became part of the artist's method for exploring new images, resulting in a dramatic expansion of his print production, plus a significant number of uneditioned prints, unique prints, charitable contributions, political statements and prints for personal use. As a student in the 1940s, Warhol had printed greeting cards for holidays and special occasions, a practice that he continued in the 1950s. His first prints of the 1970s were editioned versions of his paintings – *Electric Chair* and *Mao* [74] – which were essentially reproductions of his paintings. The political subject matter continued in his *Vote McGovern* print [75], which he contributed to promote and raise funds for the Democratic candidate's presidential campaign. Over the decade, he continued to produce prints to support the presidential campaigns for *Jimmy Carter* (1976) and *Edward Kennedy* (1980), confirming his liberal political stance.

After 1972 he fabricated the most technically complex of his prints, combining his photo-transfer process with hand-colouring, drawing, diamond dust and torn-paper collage. In the 1960s Warhol's prints were usually produced after the paintings, while in the 1970s the prints periodically preceded the paintings and began to influence his work on canvas. Exemplary among his prints is the series *Sunset* [101] originally commissioned by Philip Johnson for a hotel in Minneapolis, for which Warhol created 472 variations on the subject, each a unique print in a different colour combination. Warhol also created an editioned series of over 150 more variations, extending the notion of reproduction in printmaking just as he had challenged the cherished ideal of uniqueness in painting. The startling simplicity of composition borders on abstraction and prefigures his *Shadows*, of which he also did a series of unique prints [106].

Over his career, Warhol worked with a number of different printers. In 1977 Warhol began to work exclusively with Rupert Jason Smith. From this point onwards, the artist's printmaking accelerated, and over the course of the next decade he produced almost half of the total number of prints that he created over his career. He began to produce multiple series of prints that were discreet bodies of work. Warhol always had the uncanny ability to identify images that defined a generation. He had done so with his Pop iconography in the 1960s and did the same for the 1980s. For his American *Myths* [102], the artist selected ten mythological figures that had shaped the breadth of the American psyche from Uncle Sam to Aunt Jemima, and the Wicked Witch of the West to Santa Claus. The artist hired actors and dressed them for their roles, shooting and

selecting the Polaroids for the final screenprints. However, for *The Shadow*, the popular crime fighter of radio fame, Warhol chose himself as the subject. In this print the artist crafts a personification of himself peering out from the shadows, masquerading as a hero. Warhol continued his feverish production of prints into 1987. Although there are no paintings that are datable to the final months of his life in 1987, he issued five portfolios, including his favourite late subject *Camouflage* [99].

Over the decades of his artistic production the traditional distinctions between painting and printing, original and copy, and unique and serial images blurred, mirroring the cultural transformation inherent in the mass dissemination of photographic images in post-war America.

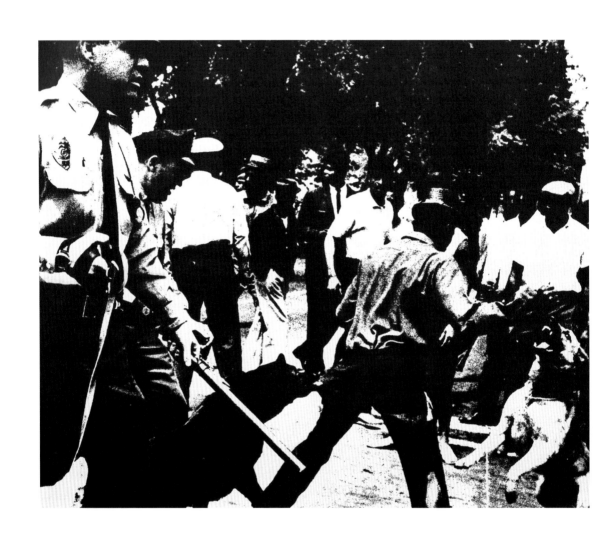

100
Birmingham Race Riot, 1964
from the portfolio *Ten Works by Ten Painters*
Silkscreen ink on paper
50.8 × 61 cm (20 × 24 in)
Wadsworth Atheneum, Hartford

101
Sunset, 1972
Editioned screenprint on paper
86.4 × 86.4 cm (34 × 34 in)
The Andy Warhol Foundation for
the Visual Arts, Inc.

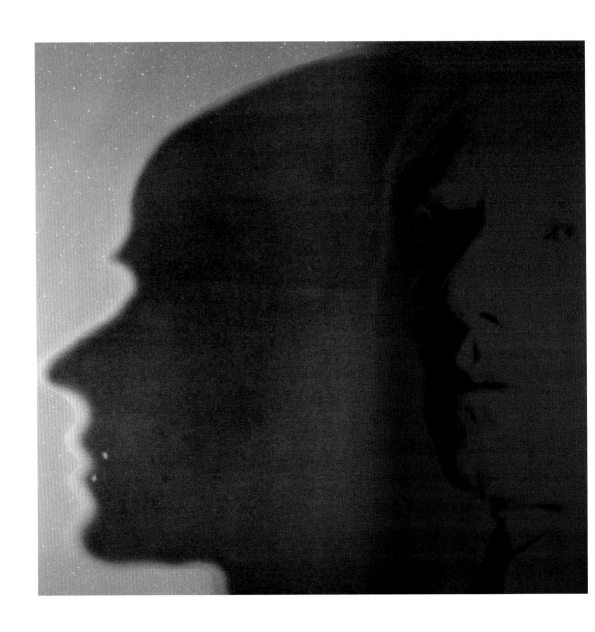

102
The Shadow, 1981
from the portfolio *Myths*
Screenprint on Lenox museum board
96.5 × 96.5 cm (38 × 38 in)
Ronald Feldman Fine Arts, New York

'I haven't peed on any canvases this week,' Warhol informed his diarist on 28 June 1977. Since his return from Paris in May, he had committed himself to painting and he charted a radically new direction with his urine paintings. In his studio, the artist was thinking about the Abstract Expressionists, who had been so prominent when he arrived in New York in 1949 as a college graduate. Nearly thirty years later, remembering those artists, he embarked on an entirely new venture: abstraction. But, with his typical penchant for paradox, he wanted to create abstractions differently. In opposition to the emphatic brushstrokes of his predecessors, he strove to make 'invisible paintings', an idea he had first attempted with his *Silver Clouds* [44]. Warhol wanted to paint without painting.

Warhol first urinated on a canvas in the early 1960s, while exploring staining canvas with natural substances, one of many experiments before he settled on the notion of projecting and painting ads. Twenty-seven years later, he developed the catalytic reaction between metallic paints and the acid in human urine to 'paint' abstractions. In the studio, Warhol and his assistant Ronnie Cutrone 'painted' on canvases that had been prepared with metallic paints, strewn across the floor, and leaned against the wall, manipulating their acidic stream to create rich, raining flows of green pigment on the elegant golden grounds. The artist worked on long stretches of canvas as well as small squares that were later assembled into larger groups, exploring the effects on various grounds of gold, silver and white. He explained that he administered Vitamin B to Cutrone, with strict instructions not to urinate before coming to work the next morning because the combination of minerals and chemicals created the colours that he sought in these works.

Warhol strove for a striking pictorial effect and emphasized the critical importance of technique in creating a successful urine painting. His aspirations were no different than for his early Pop paintings when he advocated in 1963, 'All painting is fact, and that is enough; the paintings are charged with their very presence. The situation, physical ideas. Physical presence – I feel this is the comment.' At their finest, the urine paintings resonate with the sublime grandeur of Abstract Expressionism, such as Pollock's drip paintings [84]. Certainly, Warhol is as physically involved in the act of painting as Pollock's performance of painting. Yet his works simultaneously embody the impudent snub of the very painting that they emulate. After all, urinating on a painting is the ultimate gesture of disrespect; in this case, a gesture that references Marcel Duchamp's *Fountain* [103], the Dada anti-art sculpture made by inverting a urinal. But Warhol was not making an anti-art statement. He created these canvases with artistic aspirations. These personal paintings found no American galleries who were willing to exhibit them until after his death. However, they were exhibited in Paris in 1978, when Warhol changed their name to the more socially acceptable *Oxidation Paintings* [104].

103
Marcel Duchamp
Fountain, 1964
(replica of
1917 original)
Porcelain
Height: 36 cm
(14 ¼ in)
Tate, London

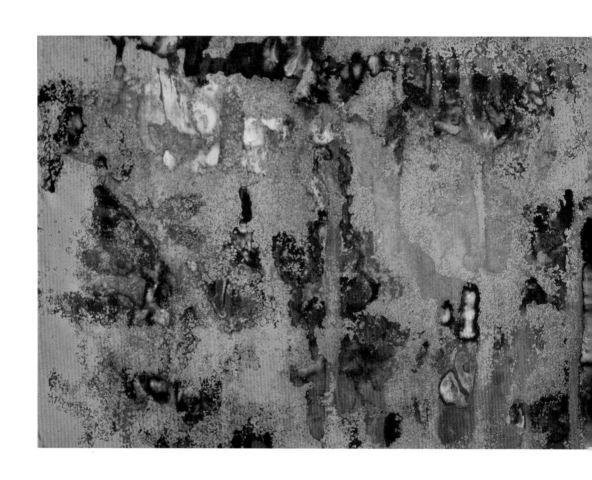

104
Oxidation Painting, 1978
Copper paint and urine on canvas
198 × 528.3 cm (78 × 208 in)
Galerie Bruno Bischofberger, Zurich

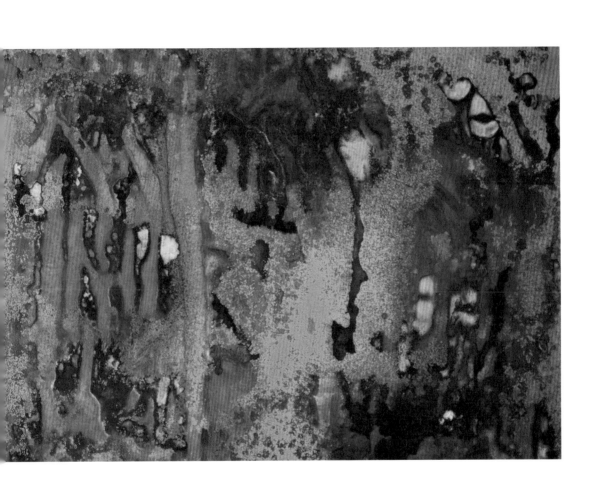

The *Oxidation Paintings* rejuvenated Warhol's energy and he wanted to continue exploring abstraction. As before, he wanted to do it differently, seeking to paint without really painting. He decided to portray shadows, as he had done portraits, in his photo-transfer, silkscreen process. *Shadows* were created in tandem with the *Oxidations Paintings*, and these two groups of works signal a dramatic shift in the artist's work, the most significant change since the advent of Pop Art in the early 1960s. In these two series of ambitious monumental abstractions, he intended to rival his predecessors, the Abstract Expressionists, but in an ironic Warholian manner.

For the *Shadows*, the artist staged a series of still life arrangements with sheets of matte board illuminated by spotlights to cast long shadows. He shot Polaroids and selected the ones to be made into acetates for silkscreen paintings. Warhol then mopped a series of 102 large, two-metre (six-and-a-half-foot) canvases, in a spectrum of colours, creating a thick impasto, and screened the shadows on top. The resulting work was designed to envelop the walls of Heiner Friedrich Gallery, in an environmental installation that recalled the *Elvis* paintings exhibition [42] at Ferus Gallery, Los Angeles in 1964, and the *Cow Wallpaper* installation [45] at Castelli Gallery, New York in 1966.

Shadows evoke deep mysteries in the dark black grounds, with brilliant colours peering through the menacing forms. The subject of these paintings is only suggested by the title. When he first saw them, the young painter Julian Schnabel (b. 1951) remarked, 'There is almost nothing on them. Yet they seem to be pictures of something and as full of imagery as any of Andy's other paintings.' The imagery recalls the memento mori

of the *Skull* paintings [78], in which Warhol at mid-life contemplates mortality. They prefigure the evocative biomorphic shapes of the *Rorschach* paintings [90], in which the totemic forms stimulate free associations from the viewer's psyche.

Heiner Friedrich exhibited *Shadows* at his SoHo gallery in January 1979 [105] and purchased the entire series for the Lonestar Foundation in advance of the opening. It was Warhol's largest show in New York since his retrospective at the Whitney Museum of American Art in 1971 and merited an article in the *New York Magazine*. Warhol thought the show looked 'great', and carried on with the series, creating other *Shadow* paintings and a unique series of prints using a variety of different shadow patterns [106]. However, at this time, the general opinion of Warhol's work was at a low ebb and he braced himself in anticipation of a critical reception. The public was unprepared for Warhol's venture into abstraction. He carried on, creating a unique series of prints. After a decade of silkscreen images of people and products, critics were surprised by the artist's radically new work, praising them as 'Warhol's best in recent years'.

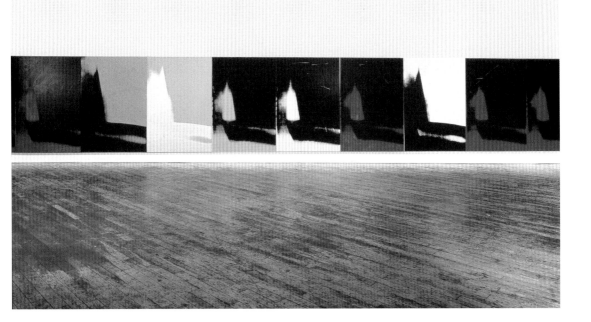

105
Installation view of 'Andy Warhol *Shadows*'
exhibition at Heiner Friedrich Gallery,
New York, 1979

106
Shadows I and *II*, 1979
Screenprint on diamond dust
on Arches paper
109.2 × 77.4 cm (43 × 30 ½ in) each
The Andy Warhol Foundation for the
Visual Arts, Inc.

FOCUS (8)

THE LAST SUPPER

Warhol joined the ranks of earlier modern avant-garde artists – including Matisse and Picasso – who treated religious subjects. Few people were aware of Warhol's private religious convictions. Alexandre Iolas's commission for Warhol to paint an homage to Leonardo da Vinci's fresco, *The Last Supper* [108], inspired Warhol to express publicly his private devotion in his art. Working continuously on this series for over a year [107], he created hundreds of paintings, prints and drawings, working with his broad repertoire of techniques: screenprinting, projections, photo-transfers, torn paper collages and painting by hand. The result is perhaps the most ambitious series of religious paintings in the twentieth century.

By the time of the commission, Warhol had developed a number of paintings, never exhibited, of religious subjects, such as *Raphael Madonna – $6.99* (1985) and some of the *Black and White Ads* (1985–6) in which he copied evangelical slogans such as 'Heaven and Hell Are Only a Breath Away', 'Repent and Sin No More' and 'Mark of the Beast'. For the Iolas commission Warhol and his studio assistants searched for reproductions of Leonardo's *The Last Supper* to use for this series and settled on three: a turn-of-the-twentieth-century chromolithograph, a 1913 line engraving and a polychrome plaster model from the local market. He used the chromolithograph as the source of the screen paintings and prints that he exhibited in Iolas's gallery in January 1987. In this installation, the artist had the paintings and prints hung directly on the wall in emulation of Leonardo's fresco. Ever searching for a paradox, Warhol did not simply reproduce the chromolithograph, he reproduced two images side by side [109]. In Catholic dogma it is a transgression to have two images of Christ in the same picture.

With these paintings Warhol expresses his reverence and irreverence simultaneously.

In some of his most innovative compositions, Warhol projected the 1913 line engraving onto his monumental canvases and, working freehand, repainted the Leonardo fresco into unique compositions with symbolic emblems [110]. A frieze of selections from Leonardo's fresco revolves around a detail of Christ and his disciples within an oval price tag, 6.99. The golden yellow silhouettes Christ's torso and serves as a halo, highlighting his head within a mandorla. Below him is the phrase 'The Big C', an obvious reference to Christ, who is surrounded by the owl of wisdom and the eagle of redemption. Warhol appropriated 'The Big C' from a newspaper headline that asks 'The Big C: Can the Mind Act as a Cancer Cure?' The source also indicates Warhol's interest in alternative medicines at this time as possible remedies for his physical ailments. The Mineola motorcycles that race across the canvas tie together a complex composition that is masterfully painted. While he publicly disavowed personal religious significance in these paintings, he did confess, 'I painted them all by hand – I myself; so now I've become a Sunday painter ... That's why the project took so long. But I worked with a passion.' In these paintings Warhol reveals his personal version of Catholicism coloured by the irony of his Pop images.

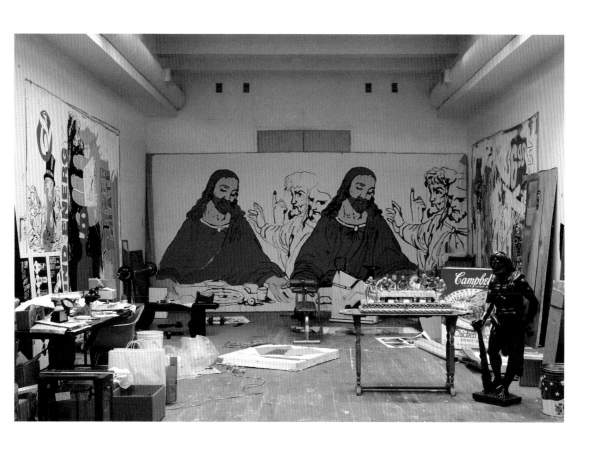

107
Warhol's studio with *The Last Supper*
in the background, in 1987

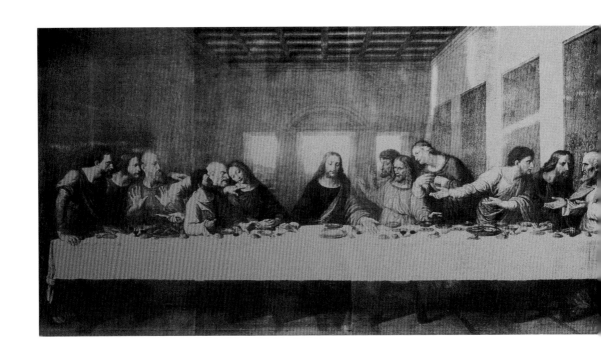

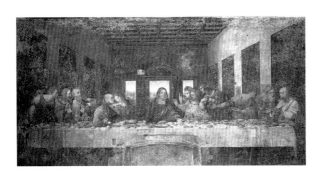

108
Leonardo da Vinci
(1452–1519)
The Last Supper,
c.1495–8
Tempera on plaster
460 × 880 cm
(181 × 346 ⅞ in)
Santa Maria delle
Grazie, Milan

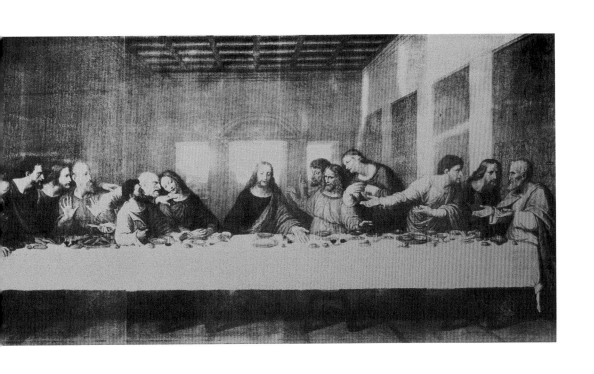

109
The Last Supper, 1986
Synthetic polymer paint and
silkscreen ink on canvas
198 × 777 cm (78 × 306 in)
The Andy Warhol Museum,
Pittsburgh

110
The Last Supper – The Big C, 1986
Synthetic polymer paint on canvas
294.6 × 990.6 cm (116 × 390 in)
The Andy Warhol Museum, Pittsburgh

1928

Andrew Warhola is born on 6 August, in Pittsburgh, Pennsylvania.

1945-9

Warhol attends Carnegie Institute of Technology, Pittsburgh, in the department of Painting and Design.

1949

He graduates from Carnegie Institute of Technology with a Bachelor of Fine Arts degree in Pictorial Design and moves to New York with classmate Philip Pearlstein, with whom he shares a studio for the summer. He begins to work as an illustrator for *Glamour* and *Harper's Bazaar*.

1950

Warhol's mother, Julia, moves to New York and lives with him until 1971.

1951

Warhol wins his first in a series of Art Director's Club Medals for graphic design.

1952

His first solo exhibition 'Fifteen Drawings Based on the Writings of Truman Capote' is held at Alexandre Iolas's Hugo Gallery, New York.

1955

Warhol obtains a contract for weekly I. Miller shoe adverts in *The New York Times*.

1956

He exhibits 'The Golden Slipper' at the Bodley Gallery, New York.

1957

Life magazine runs an article on Warhol's 'Crazy Golden Slippers'. He incorporates Andy Warhol Enterprises, Inc. The artist wins an Art Director's Club Gold Medal and an Award for Distinctive Merit for the I. Miller Shoe Company ads.

1958

He loses the I. Miller contract. Jasper Johns's first solo exhibition is held at Leo Castelli Gallery, New York.

1961

Warhol has an exhibition of five paintings in the display window of Bonwit Teller department store, New York.

1962

He exhibits *32 Campbell's Soup Cans* at Irving Blum's Ferus Gallery, Los Angeles. Warhol creates his first photo-transfer silkscreen painting, *Baseball*. His work is included in Sidney Janis Gallery's 'New Realists' exhibition and he has a solo exhibition at Eleanor Ward's Stable Gallery.

1963

Warhol begins to use the medium of the photobooth for an article in *Harper's Bazaar* magazine. Art collector Robert Scull commissions

a portrait of his wife Ethel. Warhol buys a 16mm camera and begins to make films, the first being *Sleep*. Gerard Malanga becomes Warhol's assistant. An exhibition of *Elvis* paintings is held at Ferus Gallery, Los Angeles.

1964

He moves into the Factory at 231 East 47th Street and hires Billy (Linich) Name to decorate the interior in silver. *Thirteen Most Wanted Men* is installed on the New York State World's Fair building, then painted over by order of Governor Nelson Rockefeller. He exhibits *Death in America* at Sonnabend Gallery, Paris, *Box Sculpture* at Stable Gallery, New York, and *Flowers* at Leo Castelli Gallery, New York. Warhol shoots his film *Empire* and is awarded 'Independent Filmmaker of the Year' by *Film Culture* magazine.

1965

Warhol announces that he has 'retired' from painting at the *Flowers* show at Sonnabend Gallery, Paris. His first museum exhibition is shown at the Institute of Contemporary Art, Philadelphia.

1966

Silver Clouds and *Cow Wallpaper* are exhibited at Leo Castelli Gallery. Warhol begins to manage The Velvet Underground and produces his multimedia experience entitled the 'Exploding Plastic Inevitable'.

1967

The first European museum survey of Warhol is held at Moderna Museet, Stockholm, and travels to Stedelijk, Amsterdam, and Kunsthalle, Bern. His work is shown at *Documenta 4*, Kassel.

1968

On 3 June, Valerie Solanas, a scriptwriter and regular at the Factory, shoots Warhol, who is badly injured.

1969

Warhol founds *Interview* magazine. Vincent Fremont and Fred Hughes begin to work with Warhol Entreprises.

1970

A Warhol retrospective, organized by John Coplans for Pasadena Museum, travels to Chicago, Paris, Eindhoven and London, and closes at the Whitney Museum of American Art, New York, in the summer of 1971.

1971

He designs Rolling Stones' *Sticky Fingers* album cover. With the release of the Polaroid SX70 Big Shot, Warhol begins experimenting with Polaroid cameras, which will be the primary tool for his portraits of the 1970s.

1972

Ronnie Cutrone becomes Warhol's studio assistant. Warhol's mother dies in November.

1974

Warhol moves the studio to 860 Broadway, which becomes known as 'The Office'.

1975

The artist publishes *The Philosophy of Andy Warhol (From A to B and Back Again)* with publisher Harcourt Brace Jovanovich.

1976

While travelling in Switzerland, art dealer Thomas Ammann shows Warhol the Minox 35 EL, which is the smallest camera available. Warhol buys one, and from then on he always carries a small camera with him. He began dictating his diary to his secretary Pat Hackett. It was published after his death.

1977

Warhol begins sewing together photographs, creating the series *Stitched Photographs*, which continues until 1986. He switches silkscreen printer, from Alex Heinrici to Rupert Smith. Warhol travels to Paris for the opening of the Centre Pompidou where he marvels at the tradition of European painting.

1978

He begins to work on *Oxidation Paintings* and *Shadows*, launching a new phase of his career. He also begins to market himself as a male model.

1979

Warhol exhibits *Shadows* at Heiner Friedrich Gallery, New York. He launches his first television series and *Fashion*: *Portraits of the 70s* are exhibited at Whitney Museum of American Art, New York. The artist publishes *Andy Warhol's Exposures*.

1980

POPism: The Warhol '60s is pubished by Harcourt Brace Jovanovich, co-authored by Warhol and his secretary Pat Hackett. Jay Shriver becomes Warhol's studio assistant.

1982

Warhol meets Jean-Michel Basquiat and begins collaborations. Warhol travels to Hong Kong and Beijing with Fred Hughes and photographer Christopher Makos.

1985

Warhol's 'collaborations' are shown at Tony Shafrazi Gallery, New York.

1986

Warhol exhibits *The Last Supper* at Alexandre Iolas Gallery, Milan. The television series *Andy Warhol Fifteen Minutes*, produced by Vincent Fremont, is broadcast on MTV.

1987

Stitched Photographs are exhibited at Robert Miller Gallery, New York. Andy Warhol dies on 22 February in New York of complications following gall bladder surgery, aged fifty-eight.

FURTHER READING

Callie Angell, *Andy Warhol Screen Tests: The Films of Andy Warhol Catalogue Raisonné, Volume 1* (New York, 2006)

Heiner Bastian, *Andy Warhol Retrospective* (exh. cat. Tate, London and the Museum of Contemporary Art, Los Angeles, 2001)

Rainer Crone, *Andy Warhol* (London, 1970)

Rainer Crone, *Andy Warhol: A Picture Show by the Artist* (New York, 1987)

Jane Daggett Dillenberger, *The Religious Art of Andy Warhol* (New York, 1998)

Frayda Feldman and Claudia Defendi, *Andy Warhol Prints: A Catalogue Raisonné 1962–1987*, 4th edn. (New York, 2003)

Mark Francis *et al.*, *Andy Warhol: The Late Work* (exh. cat. Museum Kunstpalast, Düsseldorf, 2004)

Pat Hackett (ed.), *The Andy Warhol Diaries* (New York, 1989)

Christoph Heinrich, *Andy Warhol: Photography* (exh. cat. Thalwil/Zurich and New York: Edition Stemmle, 1999)

Joseph D. Ketner II, *Andy Warhol: The Last Decade* (exh. cat. Milwaukee Art Museum, 2009)

Kynaston McShine (ed.), *Andy Warhol: A Retrospective* (exh. cat. The Museum of Modern Art, New York, 1989)

Eva Meyer-Hermann (ed.), *Andy Warhol: Other Voices, Other Rooms* (exh. cat. Rotterdam: NAi Publishers in co-production with the Stedelijk Museum, Amsterdam and the Moderna Museet, Stockholm with the Andy Warhol Museum, Pittsburgh, 2007)

Neil Printz and Georg Frei (eds), *The Andy Warhol Catalogue Raisonné, Volume 1: Paintings and Sculptures 1961–1963* (London and New York, 2002)

Neil Printz and Georg Frei (eds), *The Andy Warhol Catalogue Raisonné, Volume 2: Paintings and Sculptures 1964–1969* (London and New York, 2004)

Neil Printz and Sally King-Nero, *The Andy Warhol Catalogue Raisonné, Volume 3: Paintings and Sculptures 1970–1974* (London, 2010)

Carla Schultz-Hoffmann (ed.), *Andy Warhol: The Last Supper* (exh. cat. Bayerische Staatsgemäldesammlungen, Munich, 1998)

Patrick S. Smith, *Warhol, Conversations about the Artist* (Michigan, 1988)

Gene Swenson, 'What is Pop Art: Answers from 8 Painters, Part 1', *Artnews*, 62 (November 1963), pp. 24–7

Paul Taylor, 'The Last Interview: Andy Warhol', *Flash Art*, 133 (April 1987), pp. 40–4

Phyllis Tuchman, 'Pop!': Interviews with George Segal, Andy Warhol, Roy Lichtenstein, James Rosenquist, and Robert Indiana', *Artnews*, 73 (May 1974), pp. 24–9

Andy Warhol, *The Philosophy of Warhol (from A to B & Back Again)* (New York, 1975)

Andy Warhol and Pat Hackett, *POPism: The Warhol '60s* (New York and London, 1980)

PICTURE CREDITS

All artworks © The Andy Warhol Foundation for the Visual Arts, Inc., unless otherwise stated.

© The Estate of Jean-Michel Basquiat/ADAGP, Paris and DACS, London 2013: 121, 122–3 top; Photo: Rudolph Burckhardt: 53; © Julio Donoso/Sygma/Corbis: 104; © T.H. Benton and R.P. Benton Testamentary Trusts/DACS, London/VAGA, New York 2013: 14; Corbis: 11, 115, 116, 119, 126, 134, 135; © Succession Marcel Duchamp/ADAGP, Paris and DACS, London 2013: 34, 129; Courtesy Ronald Feldman Fine Arts, New York: 128; © Getty images/Fred W. McDarrah: 9 bottom, 58 top and bottom; © George Grosz/DACS, London 2013: 15; © Estate of Evelyn Hofer: 137; © Hulton-Deutsch Collection/Corbis: 78; Robert Levin/Corbis: 100; © Jasper Johns/VAGA, New York/DACS, London 2013: 30; Courtesy Kunsthalle Bielefeld: 110–1; © Roy Lichtenstein/DACS, London/VAGA, New York 2013: 32; © Christopher Makos: 4, 107; Photo Ugo Mulas © Ugo Mulas

Heirs. All rights reserved: 9 top; The Museum of Modern Art, New York/Scala, Florence: 92 top, 127; © Billy Name: 28, 52 bottom; © The Estate of Alice Neel, courtesy David Zwirner, New York: 37; © Anton Perich: 80; © The Pollock-Krasner Foundation ARS, NY/DACS, London 2013/Photo: Rudolph Burckhardt/Sygma/Corbis: 103; Courtesy Thomas Ammann Fine Art AG, Zurich: 122 bottom; Courtesy The Brant Foundation, Inc., Greenwich, CT: 26 right; Courtesy Galerie Bruno Bischofberger, Zurich: 112–13, 130–1; © Estate of Robert Rauschenberg/DACS, London/VAGA, New York 2013: 31; © James Rosenquist/DACS, London/VAGA, New York 2013/Photo: The Museum of Modern Art, New York/Scala, Florence: 33; © Estate of Ben Shahn/DACS, London/VAGA, New York 2013/The Phillips Collection, Washington, DC: 16; © Steve Schapiro/Corbis: 6, 71; © Andy Warhol Museum, Pittsburgh: 72–7; © Wols/ADAGP, Paris/DACS, London 2013/Photo Scala, Florence/BPK, Bildagentur für Kunst, Kultur und Geschichte, Berlin: 8.

LIST OF WORKS